No! Contemporary American DADA

Henry Art Gallery

**University of Washington
Seattle**

Prepared in conjunction with the exhibition "NO: Contemporary American Dada," held at the Henry Art Gallery, University of Washington, Seattle, November 8, 1985–January 19, 1986.

Library of Congress
Catalog Card Number: 85-81311

ISBN: 0-935558-17-9

Edited by Joseph N. Newland

Art Direction and Design by
Douglas Wadden

Text type set in Helvetica by Henry Art Gallery/Department of Printing, University of Washington. Display type set in Helvetica by Thomas & Kennedy, Seattle.
Printed on Mitsubishi New-V-Matte and bound in Bon Ivory by Nissha Printing Co., Ltd., Kyoto, Japan.

This catalogue has been funded in full by the Henry Gallery Association.

Henry Art Gallery
University of Washington
Seattle, Washington 98195

Staff of the Henry Art Gallery

Harvey West, Director
Vickie R. Maloney, Assistant Director
Joseph N. Newland, Editor of Publications
Chris Bruce, Curator
James R. Crider, Adjunct Curator, Textile Collection
Judy Darlene Sourakli, Registrar
Blair Rice, Secretary to the Director
Paul A. Cabarga, Bookstore Manager
Jill Clark, Accounting Assistant
Sara Denman, Assistant Bookstore Manager
Ed Vegsund, Custodian

Mrs. John E.Z. Caner, Director,
Henry Gallery Association

Foreword

"NO: Contemporary American Dada" is the companion publication to the Gallery's exhibition of the same name, featuring artists who present confrontational issues and take an uncompromising stand on them. The issue of negation has become an important one in today's American art, and different aspects of it can be found in the works of Edward Kienholz and Nancy Reddin Kienholz, Hans Haacke, Chris Burden, Llyn Foulkes and the rock videos that have been selected for this exhibition. The catalogue will be published in two parts, of which this is the first; in it are an essay on negation in 20th-century art and profiles of the artists and their past work. Part 1 provides a foundation for viewing the works in the exhibition, which, because most are being created specifically for this showing, will be documented in Part 2. It will be published after the exhibition has been installed and photographed.

Negation became the curatorial concept behind this exhibition as the result of a series of discussions on Dada in American art between myself and Dr. Ileana B. Leavens, author of the essay included here. Her research on the "291" circle and the emergence of Dada ideas there provided the basis for a definition of Dada that can be summed up by the word "NO" — anti-aesthetic in the world of art and anti-authority in all realms of life. The exhibition is composed of contemporary works because they address issues that are alive today and because the artists are able to speak for themselves. The purpose of this project is to study some of the concepts, personalities and art works that compose a commanding and important segment of our modern art.

The investigation of generative ideas in American modern art is a prime focus of the Gallery's special exhibitions, publications and lectures; the other is the study of our nation's art history. Exhibition-related programs are the most obvious activity of the Gallery; less visible are the care and use of collections and the efforts of the Gallery staff and the Henry Gallery Association's patrons and members necessary to build a comprehensive university museum program for the 21st century. Special programming has been primary since the museum opened in 1927, and projects such as "NO" show why it is one of the most exciting ways of examining ideas at the Henry.

To understand contemporary American Dada one must first understand the artists' concepts. Although there is an enormous range, all share at least one common purpose: challenging the status quo. To express their ideas these artists often use similar materials and techniques, e.g., found objects. They are also characterized by an unusual inventiveness in finding the proper means of presentation, because it is the concept that is paramount; its expression is a natural outgrowth. And, while all these artists wish their message to be heard and understood, their capability to reach the public varies greatly. The private, introspective portraits of Llyn Foulkes are relatively unknown even in this country, and while the Kienholzes and Haacke especially are well known in both Europe and America, their audience too is limited when compared to that of the commercial rock video producers. They can reach millions of people almost instantly.

The organization of this exhibition has been characterized by an unusually close cooperation with the artists involved, and I would like to express our deep gratitude to them for making "NO" such a challenging and rewarding experience for the viewer. A special note of appreciation goes to Dr. Leavens for her exceptional essay, which illuminates one specific aspect of that contradictory phenomenon called Dada. It has been my pleasure to work with her over a long period on the conceptual base of the entire project, which because of the elusive nature, cynicism, wit, trickery, and unpredictability of Dada artists required an especially dedicated and discerning observer. Dr. Leavens has been a tireless worker and a great friend during the entire preparation period. We would like to thank all those who provided photographs for the catalogue as well as the Collection of American Literature, Beinecke Rare Book and Manuscript Library, Yale University, for permission to quote from material in the Alfred Stieglitz archive.

Chris Bruce, the Henry Art Gallery's curator, worked with me on shaping the exhibition and its inclusions, cooperating closely with the artists on the installations and many complex logistical details. His insight into the artists' creative process is reflected in their biographical profiles, which are a joint effort with Joseph N. Newland, the Gallery's editor of publications, who also worked closely with Dr. Leavens on her essay. The format and form of the book reflect the teamwork of the editor and the designer, Douglas Wadden, and I would like to commend Mr. Wadden for once again making a book design appropriate to the content. I would like to thank also my secretary, Blair Rice, and Judy Sourakli, registrar, for their work on the project's administrative side. Assistant director Vickie Maloney has done her usual superb job on publicity.

Our collective thanks are also due to the Henry Gallery Association, headed by its director, Mrs. John E. Z. Caner, and president of the Board of Trustees, H. Raymond Cairncross, without whose support neither the exhibition nor publication could have taken place. Our special gratitude is extended to PONCHO, a long-time supporter of the Henry Gallery Association's publication fund. An especially generous grant from PONCHO underwrote the entire production costs of this catalogue.

Harvey West
Director

Table of Contents

For his patience during my research and
writing, I dedicate this to my husband, Bill.

No!

Ileana B. Leavens

1. Different life-styles have included idiosyncratic dress or behavior, the Bohemian life and/or Decadence, this last superbly represented by Huysman's Des Esseintes. Idiosyncratic dress is best exemplified by the Baroness Elsa von Freytag-Loringhoven, who has been associated with the so-called New York Dada movement. Little is known about her background, but according to descriptions, her attires included: a topless turban with feathers; tin cans; trinkets; silk and paper flowers; red celluloid fishes; foreign coins; and other odds and ends. A description of one of her more conservative outfits appears in Margaret Anderson, *My Thirty Years War* (New York: Covici, Freide, 1930), p. 178. Other accounts indicate that at least once she shaved her head and painted it purple.

No! How many times has this word been said or written by the peoples of the world? It was uttered by our primitive ancestors, and will continue to be cried out as long as man exists. "No," "nien," "nyet," "non," . . . are but variations of an emphatic negativism of ambivalent connotations. For "no" denotes both authority and rebellion, aggression and defense. As rebellion against tradition, "no" is at first a rejection of the accepted or what is usually acceptable followed by the acceptance of the unaccepted.

NO! opposes society's collective concept of "rationality," and therefore it has been independent, irrational and intuitive; by subscribing to the eclectic it has been anti-authority; it has also been anarchic, confrontational, provocative and irreverent. As a reaction to the establishment, rebellious NO!s have been expressed in various ways: in anti-social behavior and/or intellectually, through the written and spoken word, in music, dance and the visual arts.

As a reaction to civilized society and its culture, such rebellion has taken two contradictory positions: uninvolvement and involvement with the existing authority. Uninvolved or disengaged rebellion has appeared as a literal escape, such as Gauguin's utopian search for the primitive, the creation of different life styles, or in various degrees of indifference to life. At present a search for the primitive is close to impossible, considering the inroads civilization has made throughout the world. Alternative life-styles and indifference are at best dichotomous states of affairs, as they consist of disengagement through rejection and involvement through the shock value of the newly different. Examples abound from Gautier and the Decadents in the 19th century to present-day punks.[1] But I am not interested here in these escapist aspects of rebellion. I am concerned with rebellion as involvement, and especially that which hopes to lead to a re-evaluation of society itself, its nature and its illnesses.

Involved rebellion has always had political and ethical as well as aesthetic connotations, and it has used for its weapons society's own cultural products, both "high" or "low." It has also manifested different degrees of engagement. In the visual arts, involvement has appeared as critiques of aesthetics, artful criticisms of life, a confrontative critical art and, at its most involved, as public confrontation. At the lowest level of involvement is the modern rebellion, mainly a reaction to and critique of academic aesthetics, as well as a criticism of itself through a series of alternative proposals; it embodied an aesthetic sensibility reflecting the character of its times, but a spirit manifested mainly through art experiences and art expressions, one which seldom dealt with social and political issues. In the 19th century, the rebellious artists , the modern artists, were primarily concerned with art for art's sake rather

2. By "modern," uncapitalized, I mean the aesthetic rebellion which appeared in the late 18th century, and ranged from the Romantics through Symbolism.

3. Géricault, for example, attacked the French government in his *Raft of the Medusa*, 1818-19. A government vessel had been allowed to sail though it should not have been, and it had foundered with considerable loss of lives. The event was a political scandal. Daumier was imprisoned for his caricatures of the bourgeois king as a Gargantua. Courbet was held responsible for the destruction of the Vendome column, imprisoned, and was then fined. Unable to pay, he fled to exile.

4. As quoted in Malcom Bradbury and James McFarlane, *Modernism* (Harmondsworth: Penguin Books, 1978), p. 33.

5. As quoted in Ibid., p. 20.

6. As quoted in Ibid.

7. By "Modernism" I mean the art movements which emerged during the first 10 or so years of this century; it was both a continuation of and a reaction to modern 19th-century "-isms." At its birth Modernism counted Cubism, Futurism, German Expressionism, Dada and Surrealism among its manifestations.

8. Dada's relations to Futurism were ambivalent. Of all Modern -isms Futurism had been the only one to be militant, but it had stopped short of an all out radicality, and though it had made screeching attacks on the past and its culture, Futurism had worshiped war and technology. Dada was the very opposite. It even rejected the expressionist milieu from which several Dadas had emerged. But, as Dada is self-contradictory, George Grosz used an expressionist style in his brutal attacks on society and the political games it plays. That approach has survived today, under the Neo-Expressionist label.

9. Stephen Spender, "Moderns and Contemporaries," in *The Idea of the Modern in Literature & the Arts,* ed. Irving Howe (New York: Horizon Press, 1967), p. 44.

10. Ibid.

than art for life's sake.[2] But a minority, Goya, Géricault, Daumier, Courbet and to a lesser extent Millet, also referred to contemporary political and social issues, and even suffered when they translated these views into action, e.g., Daumier and Courbet.[3] Such involved artistic rebellion meant a direct confrontation with the authorities, as the rebellious artist expanded his arena of action from art to life.

But by the outbreak of World War I a new change in sensibility had taken place, and one which set the tone for our present way of life and thoughts. It came into being when artists and writers alike realized that their world was not quite like that of the past, even though there was not agreement as to exactly when this change had occurred. Virginia Woolf, for example, considered that "on or about December 1910 human nature changed . . . All human relations shifted. . . . And when human rela-tions change there is at the same time a change in religion, conduct, politics and literature."[4]

In 1930 Herbert Read remarked that "the contemporary revolution . . . is not so much a revolution, which implies a turning over, even a turning-back, but rather a break-up, a devolution, some would say a dissolution. Its character is catastrophic."[5] And as late as 1954 C. S. Lewis wrote: "I do not think that any previous age produced work which was, in its own time, as shatteringly and bewilderingly new as that of the Cubists, the Dadaists, the Surrealists, and Picasso has been in ours."[6] This pinpoints the new aesthetics that developed from these changes: Modernism.[7]

Modernism was a mushrooming of different movements which in more or less modified form have continued to the present. They appeared in response to the emergence of our modern world and its life-style, a world dominated by technology and depersonalization and by an ever increasing multiplicity of world problems of international dimensions, yet a world that continues to stress nationalism, as it did during World War I. Of these Modern rebellions the most extreme was Dada: it not only rejected tradition but the Modern "-isms" as well, and in its confrontation with them, set the modern spirit in action.[8]

Describing the modern artists' responses to their world, Stephen Spender wrote: "The faith of the moderns is that by allowing their sensibility to be acted upon by the modern experience of suffering, they will produce, partly as the result of unconscious processes, and partly through the exercise of critical consciousness, the idioms and forms of a new art. The modern is the realized consciousness of suffering, sensibility and awareness of the past."[9]

He contrasts to the modern, the "Voltairean 'I'," an ego that "criticizes, satirizes, attacks . . . in order to influence, to direct, to expose, to activate existing forces. . . . The faith of the Voltairean egoists is that they will direct the powers of the surrounding world from evil into better causes through the exercise of the superior social or cultural intelligence of the creative genius, the writer prophet."[10]

Following Spender's terminology, I am inclined to consider Dada as a variation (or travesty) of the "Voltairean 'I'" rather than place it completely within the modern spirit. Like the "Voltairean 'I,'" the

"the real dadas are against DADA"

11. The political character of Dada was mostly manifested in Berlin, with George Grosz, John Heartfield and others. For an excellent account of the political aspects of Dada, see Christopher Middleton, *Bolshevism in Art and Other Expository Writings* (Manchester: Carcanet New Press, 1978), pp. 38-61.

12. Spender, "Moderns," p. 44.

13. As quoted in Ben Hecht, *Letters from Bohemia* (Garden City, New York: Doubleday & Company, 1964), pp. 138-39.

14. Tristan Tzara, "Dada Manifesto on Feeble Love and Bitter Love," *Seven Dada Manifestos and Lampisteries* (New York: Riverrun Press, 1981), p. 38. Emphasis added.

15. A few earlier artists had been almost dada in character, before Dada began as a movement : Goya, Daumier and Courbet for example. But Goya for one walked the fine line between revolt and subordination to the Spanish court. The more outspoken Daumier chose to adapt himself to the dictates of governmental policies, even though he had suffered by those same policies. And while Courbet may be considered the first scandalous painter of modern times, he was so in tune with socialist ideals that he did not venture to question them. Besides, Courbet asked for the public's understanding of his work—for a dada that understanding is immaterial. For him, the public mainly exists to be insulted, or at the very least shocked. The notorious Théophile Gautier and the Decadents cannot be considered as true dadas, even if they did develop shock as a fine art. Extravagantly dressed, smoking hashish and giving wild parties, they failed to confront the public with its own frailties. They publicized the idea of "art for art's sake" and did not arrive at "art for life's sake." Furthermore, most of these precursors adhered to a number of principles. Dada (the movement) had no principles, except being, by its own volition, a moral force at times, or purely destructive at others; it was not subordinate to any particular political, religious, social or philosophical ideology, even though several dadas did succumb to political rhetoric. Dada did not cater to patriotism, duty and morality. Dada annihilated the concept of nationalism, and thereby the notion of duty that it implies.

Dadas for the most part were activists, in the widest sense of the term. But in contrast to the "rationalist, sociological, political and responsible,"[11] writing of the "Voltairean 'I,'" the Dada's writing is irrational, antisocial, "irresponsible" and for the most part apolitical. And yet the Dadas shared with the "Voltairean 'I'" the capacity of being "clear sighted social prophets in a world of confusion."[12]

In contrast to the Modern, Dada was existential in character; it encompassed all facets of behavioral and intellectual negation. It even rebelled against itself. George Grosz, a prime figure in Berlin Dada, stated:

We are, I shall say, revolutionists; whatever is more important than one human being we are prepared to revolt against. Our final battle cry will be, "down with the Dadaists." Also "down with Dadaism." At that time . . . I will be proud to fight as a traitor, which is the secret of progress.[13]

In his own manner Grosz had echoed Tzara's manifesto: "the real dadas are against DADA."[14]

In its penchant for the negative, Dada carried negation to the very limits of meaning; it created a topsy-turvy world in which rationality was replaced by the irrational, art became anti-art, aesthetics were replaced by anti-aesthetics and banality was exalted as art. As a critique of the Modern, Dada introduced an alternative; as a critique of itself it proposed no alternatives.

Dada, however, was more than another critique in the evolution of modernist criticality, for Dada arose from the gathering of rebels sharing an unusual attitude to life, one independent of individual backgrounds, nationalities and ideas. This state of mind I call dada.[15] What is dada?

Whenever there is an independent spirit accountable only to himself, questioning all traditions yet giving rise to no rules, respecting all individual rights and self-expression, we find a dada. And when dadas coalesce, we find a movement: Dada. But Dada is more than a particular aggregate of extremist individuals (which can exist in an ivory tower); Dada is a direct confrontation with society in which individual anarchism is acquiescent to group activities. As dadas can exist independently of any given Dada movement, what I will call DADA is the sum total of individual dadas and the diverse manifestations of Dada. Distilling from each their rebellious essence, DADA is the most complex and most radical form of negation.

DADA is superbly irreverent; it targets for abuse all society.

16. I have dealt with Dada and the trickster in an unpublished manuscript "Trickster or Dada?," 1984. I wish to thank Joseph Newland for bringing this topic to my attention.

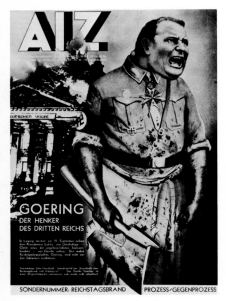

John Heartfield (German, 1891-1968), *Goering: The Executioner of the Third Reich*, cover for *Arbeiter Illustrierte Zeitung (Workers' Illustrated Newspaper)* 14 September 1933 (vol. 12, no. 36), photomontage, 14 1/2 x 10 5/8 in (37 x 27 cm). The Museum of Fine Arts, Houston, Museum Purchase with Funds Provided by Mr. and Mrs. Max Herstein (Photo: A. Mewbourn). Text, lower left: "In Leipzig on September 21, four innocent men, victims of one of the most atrocious violations of justice, will stand trial along with the agent of the provocateur Lubbe. The real arsonist of the Reichstag fire, Goering, will not appear before the bar." "Photomontage: John Heartfield. Cover picture of the 'Brown Book on the Reichstag Fire and the Hitler Terror.' The face of Goering is taken from an original photograph and was not retouched."

As the most extreme rebellion, DADA has a spiritual kinship with anarchism, and DADA's penchant for chaos is certainly anarchic in character. But DADA differs from anarchism in that it does not uphold anarchism's destructive character. Neither is it a political theory stemming from man's intellect, for DADA acknowledges no "-isms" and assumes no preconceived notions: it accepts some givens, but mostly rejects in a continuous process of inquiry, questioning what the past had to offer, what the present offers, and even what the future might offer.

The questioning character of DADA, and its many NO!s have led it to experiment fully with art and aesthetics, carrying them beyond the specific to the universal, wherein opposites are equal, "reason" gives way to "unreason," and art and life are one. Thus DADA is ambivalent and has displayed many and often contradictory facets: it has been both earthly and spiritual, personal and impersonal, childish and sophisticated, ceremonial and banal. It has been both political and apolitical, constructive and destructive, fragmentary and synthetic, while at times underlying any seriousness of purpose there is a unique humor: a mixture of parody, derision, irony and indifference. In its protean ability to remain undefined, in the complexity of its character, and in its self contradictions, DADA resembles the archetypal trickster.[16] The trickster too is at all times an advocate of uncertainty. Even as the transformer, he is, like DADA, both creator and destroyer since he may bring both good and harm; he is comic and grotesque, and in principle he is stupid and ambiguous. At times he becomes his own victim.

Like the trickster DADA is superbly irreverent; it targets for abuse all society: the masses, the intellectuals and the government as well as their acknowledged ideas of duty and righteousness, morality and patriotism, those vague concepts for which men fight, kill and die. Rejecting all Western traditions, denuding culture of all its trappings, DADA goes to the very roots of mankind. And in exchange, DADA, like the trickster, proposes its own morality. Like the trickster DADA has been in constant flux, and acting through individual rebels, DADA continues in the present, though it has ceased as a movement.

"In all phases of human activity the tendency of the masses has been invariably towards ultra conservatism."

17. The earliest compilation in English of historical Dada is Robert Motherwell, ed., *The Dada Painters and Poets: An Anthology* (New York: George Wittenborn, 1951). For bibliographic information on the subject, see the installments of the up-to-date bibliography compiled by the Dada Archives and Research Center at The University of Iowa, published in its journal *Dada/Surrealism.*

18. Quoted in Ileana B. Leavens, *From "291" to Zurich: The Birth of Dada* (Ann Arbor: UMI Research Press, 1983), p. 9.

19. Weston J. Naef, in his book *The Collection of Alfred Stieglitz* (New York: A Studio Book, 1978), pp. 50, 74-78, 106, 118, 120, 128 et passim, referred to Stieglitz's capability of offending his friends and followers. Part of this originates from Stieglitz's own personality and beliefs; at times it was a question of age, with members of the younger generation such as de Zayas rebelling against the old, Stieglitz. See also Leavens, *From '291,"* pp. 123-25; 130-33.

20. Paris Dada did not come into full swing until after Tzara went there. Tzara arrived in early January 1920; some three weeks later the first Dada scandal was organized. While Tzara's cult of negation was quickly accepted, internal conflicts soon appeared, and by 1921 were public. Tzara, like Stieglitz, was not able to hold a group together.

21. Interview with Alfred Stieglitz, *Evening Sun,* 23 April 1913. Emphasis added.

22. As quoted in Naef, *The Collection*, p. 128. Emphasis added.

Marius de Zayas (Mexican, 1880-1961), *Theodore Roosevelt,* c. 1913, photogravure in *Camera Work* 46 (April 1914), p. 43. Courtesy Seattle Public Library (Photo: Steven J. Young).

Dada as a movement was a complex and varied phenomenon, stemming from diverse personalities and motives.[17] Some dadas were idealistic, like the German Hugo Ball and the American Alfred Stieglitz; some were nihilistic like the Rumanian Tristan Tzara and the Frenchman Marcel Duchamp, and also Francis Picabia, of Hispano-French origin. Notwithstanding the internationality of backgrounds and individual differences, they all shared a common goal: to attack authority.

The attitude and paradox of Dada's NO! is typified by the character of two Dada leaders: Alfred Stieglitz and Tristan Tzara. Stieglitz's negativism and rebellion had been nurtured for years:

From the time I was a child I never liked to do things according to rules. Whether it was with Parchesis or Steeplechase, or any other game, I always made my own rules, my own game . . . as to doing things according to rule, I would feel, if people said it must be done in a certain way, that I could not accept that. I would immediately feel it could be done another way. . . . And I would feel that in time the rules would have to be changed.[18]

Even when as a photographer he had achieved worldwide recognition Stieglitz was still a troublemaker—he went against all the academic tenets of acceptable photography and popular taste, and his zeal placed undue burdens on his relations with other photographers and even with his followers.[19]

Stieglitz, like Tzara, was a magnetic personality, and like Tzara he was fully engaged in his rebellion. Tzara acted within the Cabaret Voltaire and then in Paris Dada, in which he played a pivotal role;[20] Stieglitz's outright rebellion took shape as the Photo-Secession and then as a gallery: "291." Around Stieglitz gathered a group of rebels who were to take the Secession idea beyond photography and, some of them, in true dada fashion, took it beyond art and into life. The rebellious character of the Photo-Secession was not only indicated by its name. Stieglitz himself wrote that the idea of the Secession was **"neither the servant nor the product of a medium. It was a spirit."**[21] And the Secession first manifesto was couched in the rhetoric of social radicalism:

In all phases of human activity the tendency of the masses has been invariably towards ultra conservatism. Progress has been accomplished only by reason of the fanatical enthusiasm of the revolutionist, whose extreme teaching has saved the mass from utter inertia. . . . What is today accepted as conservative was yesterday denounced as revolutionary. It follows then that it is to the extremist that mankind largely owes its progression. . . . The Secessionist lays no claim to infallibility, nor does he pin his faith to any creed, but he demands the right to work out his own photographic salvation.[22]

23. Reprinted in *Camera Work,* 42/43 (April-July 1913), p. 51.

24. Letter to Sadakichi Hartmann, dated 22 December 1911, Stieglitz Archives, Beinecke Library, Yale University. Not all approved of this method. Clifford Williams, an American painter, wrote: "I have not [the] taste for many things you do—I think the continual republishing of criticism which illustrates the stupidity, change, development of critics, gives wrong proportion to criticism and material criticized—whereas the criticism preserved and used finally to prove historically an argument would seem better and in the meantime feed the hungry more amply. But I realize that you have an idea in doing this— that it is all part of your technic and the fact that you do it and in accordance with your ideals is the thing for which I am so thankful" (Letter to Alfred Stieglitz, dated 24 July 1914, Stieglitz Archives, Beinecke Library, Yale University).

25. Gabrielle Buffet-Picabia, quoted in Arturo Schwarz, *New York Dada: Duchamp, Man Ray, Picabia* (Munich: Prestel-Verlag, 1973), p. 158.

26. Robert E. Haines, *The Inner Eye of Alfred Stieglitz* (Washington, D.C.: University Press of America, 1982), p. 82. Emphasis added.

Alfred Stieglitz (American, 1864-1946), *Spiritual America,* 1923, photograph. Philadelphia Museum of Art, Alfred Stieglitz Collection.

When the Little Galleries of the Photo-Secession became simply "291," the Secession Spirit was transformed into the "spirit of '291'": "a revolt against all authority in art, in fact, against all authority in everything."[23] This, in essence, was the Dada spirit. It was not a passive rebellion; it was extremely active within the confines of a gallery. It was an engaged rebellion whose weapons were exhibitions of the most advanced Modern art and a publication, *Camera Work.* The exhibitions purposely shocked the public and critics out of their complacent attitudes; the critic's reactions were then reprinted in *Camera Work* to illustrate the "pathetic conditions" of art criticism in New York while "affording Europe, at least, much amusement."[24] Thus as a dada, Stieglitz flung the products of society's own culture, its art, its ideas and its media, back upon society, and made it a subject of ridicule. But the spirit of "291" and its rebellion went beyond aesthetics, for *Camera Work* also included "articles highly anarchic for that time, attacking capitalism, easy success and money. . . ."[25]

Though Stieglitz's NO! generally appeared as confrontation, it also took shape as an unending search for an ideal. Four years before his death in 1946 he observed:

I am told that once upon a time there was a man named Diogenes looking for an honest man. . . . I too, am on a search, maybe more difficult than the one of Diogenes. I happen to be looking for an intelligent American. [26]

He failed.

Years earlier, he had summed up his views in his satiric *Spiritual America,* 1923, a photograph in which a gelding's loins are a metaphor for the nation's spiritual sterility.

Dadas attempted to redefine the moral values of a world which, as they saw it, had lost its sense of morality.

27. Translation from Motherwell, *Dada Painters*, p. 81-82. A facsimile of the original as published in *DADA* 3 can be found in Michel Sanouillet, *DADA: Réimpression intégrale et dossier critique de la revue publiée de 1916 à 1922 par Tristan Tzara* (Nice: Centre du XXe siècle, 1976), vol. 1, p. 56.

28. World War I had been a brutal awakening from the delusion of security of the prewar period. Four years before the outbreak of hostilities, Norman Angell had theoretically, rationally, proven that a war would be impossible. By impressive examples and incontrovertible arguments (which incredibly are being echoed today), Angell had shown that due to the existing interdependence of nations both victors and vanquished would suffer equally. Therefore no nation would be so foolish as to break the status quo. Angell's book, *The Great Illusion*, became a success, and the great delusion was turned into a cult. Mankind was lulled into a false security. Even when the cannons roared, August 1914, mankind still clung to wishful thinking: the war was to be of short duration. It was not, and during the next four years, as the war grew and spread, it was conducted as a systematic, rationalized slaughter, where men were reduced to mere instruments of destruction. For a description of the war, see Barbara Tuchman, *The Guns of August* (New York: MacMillan, 1962).

29. English translation of Hugo Ball, *Cabaret Voltaire*, 15 May 1916. *Cabaret Voltaire* was the first publication by the Zurich Dadas. Translation and facsimile are in Motherwell, *Dada Painters*, pp. xix and 30.

30. Jean [Hans] Arp, "Dadaland," as quoted in Hans Richter, *Dada: Art and Anti-Art* (New York: Harry N. Abrams, 1965), p. 25.

Francis Picabia (French, 1879-1953), *The Blessed Virgin*, ink. Present whereabouts unknown. Reproduced in *391* 12 (March 1920).

Even more vehement was Tzara, whose raw negativism was expressed in his Dada Manifesto of 1918:
Every product of disgust capable of becoming a negation of the family is dada; a protest with the fists of its whole being engaged in destructive action: dada; knowledge of all the means rejected up to now by the shame faced sex of comfortable compromise and good manners: dada; abolition of logic, which is the dance of those impotent to create: dada; of every social hierarchy and equation set up for the sake of values by our valets: DADA; of every object, all objects, sentiments, obscurities, apparitions and the precise clash of parallel lines are weapons for the fight: DADA; abolition of memory: DADA; abolition of archaeology: DADA; abolition of prophets: DADA; abolition of the future: DADA; absolute and unquestionable faith in every god that is the immediate product of spontaneity: DADA;. . . Freedom: DADA, DADA, DADA, a roaring of tense colors, and interlacing of opposites and of all contradictions, grotesques, inconsistencies: LIFE. [27]

The Dada movement, as it developed in Europe during World War I, was a total attack on the social, artistic and political establishments that had led to that war. But it was more than a blind, undirected outburst, for in questioning established attitudes and traditions, Dadas attempted to redefine the moral values of a world which, as they saw it, had lost its sense of morality.

Why did this particular conflict serve to catapult Dada as a moral, and at times political, force in Europe? Seventy years later, and accustomed (?) to the idea of a nuclear holocaust, we fail to consider that prior to the Great War, no other bloodshed had been of the magnitude and impersonality of that one. For the first time toxic gases, air raids, tanks and submarines were introduced, and for a generation conditioned to expect a certain amount of personal involvement, even within man's inhumanity to man, World War I marked the end of an era, and the beginning of ours.[28]

Outraged by the savagery of the war, Hugo Ball, Emmy Hennings, Jean Arp and others opened the doors of the Cabaret Voltaire as a meeting ground for "independent men—beyond war and Nationalism—who live for other ideals."[29]
Disgusted by the slaughter of the World War in 1914 we devoted ourselves in Zurich to the arts. While the thunder of the guns roared in the distance, we sang, painted, pasted, wrote poems for all we were worth. We sought an elemental art to cure men from the madness of the age and a new order which would establish the balance between heaven and hell. We sensed that gangsters would appear who in their obsession with power would simply use art to brutalize mankind. [30]

31. Richard Huelsenbeck, "Zurich 1916, As It Really Was," in *The Era of German Expressionism,* ed. Paul Raabe (Woodstock, N.Y.: The Overlook Press, 1974), pp. 169-71. Emphasis added.

32. George Grosz, *George Grosz: An Autobiography* (New York: Macmillan, 1983), p. 140. As should be expected, a somewhat different version appears in Ben Hecht, *Letters from Bohemia,* p. 143.

33. Ben Hecht, *A Child of the Century* (New York: Playbill/Ballantine Books, 1970), p. 306.

34. Thus in America during the teens, when Modern art itself was causing a scandal, seldom do we find any direct pronouncement from a Modern artist about social and political problems, much less militancy; during the twenties (when Modernism in America was being domesticated) few Modern artists proclaimed their views even on the highly publicized and world-wide known Sacco and Vanzetti case.

35. Sadakichi Hartmann, "De Zayas," *Camera Work* 31 (July 1910), p. 31.

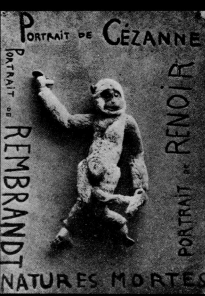

Francis Picabia (French, 1879-1953), *Portrait of Cézanne, Portrait of Rembrandt, Portrait of Renoir, Still Lifes,* 1920, toy monkey and oil on cardboard. Present whereabouts unknown. Reproduced in *Cannibale* 1 (25 April 1920).

Their violent reaction to the war set the tone for future intellectual rebellions in this century:

Dada, mainly at the outset of the Cabaret Voltaire and then later in Berlin, was a violently moral reaction . . . I would like to say that Dada developed into an artistic reaction after starting as a moral revolution and remaining one—even when the artistic question seemed to dominate.

In those days I associated with the Cabaret Voltaire and Dadaism because I realized that some form of cultural protest (and Dadaism was never anything more) was necessary and this was where I could accomplish something. . . . That Ball should call his cabaret "Voltaire" indicated that he was obsessed by cultural criticism. . . . The Cabaret Voltaire . . . was where people were prepared to express opinions which could not be expressed elsewhere. That these opinions were mainly on cultural matters was simply because we were intellectuals.[31]

This type of cultural protest cropped up in Chicago in 1923 with Ben Hecht, a newspaper correspondent and novelist/playwright. Hecht had been in Berlin during the last days of the War. There he met George Grosz, as well as other members of the Berlin Dada group. According to Grosz, Hecht was the guest of honor at an important Dada happening, in which six typewriters raced against six sewing machines, all this accompanied by a tournament of insults.[32] The Dada experience proved fruitful. After his return to Chicago, Hecht founded *The Chicago Literary Times,* whose policy, as Hecht himself described it "was to attack everything."[33] Like many others of its kind the publication was short lived, but it was a rebellious voice in a period of political conservatism, at a time when Modern art, in itself a rebel, seldom took notice of social or political issues.[34]

Hecht's *Times* echoed in the twenties the satire found at "291" in the teens. One such manifestation had been a puppet show staged by caricaturist Marius de Zayas. *Up and Down Fifth Ave.,* 1910, was "a whole épopée, every page a human life told in a swift and summary way, a protest against the smug and equalitarian organization of life, against the monstrous stupidity of conventions, parades and badges, and the hypocrisy of morals—a wonderful synthesis of the grandeur and shame of the large city [New York]."[35] Three years later, de Zayas outdid himself. In a series of caricatures highly abstract in character, and so esoteric as to be unintelligible, de Zayas satirized not only his fellow men, but caricature itself. De Zayas himself said the drawings were not art, but a graphical and plastic synthesis os of individuals. Their exhibition at "291" and publication in *Camera Work* placed them in an art context; but as a spoof on the art tradition of portraiture and caricature, they were anti-art.

This de Zayas exhibition of March 1913 was not the only example of the anti-traditional views at "291." As a rebellion against everything, "291" outdid even the Armory Show, then taking place. The Armory Show was **the** large scale introduction of Modern art to the American public, and it caused a scandal. Since the critics and public alike had singled out Marcel Duchamp and Francis Picabia for their attacks, Stieglitz invited Picabia to have a one-artist show at the

"Rebellion is life."

36. Picabia and his wife had arrived in New York for the Armory exhibition, and soon took the well-traveled route to "291."

37. He said, "To be what people call anti-art is really to affirm art, in the same way that an atheist affirms God. The only way to be anti-art is to be indifferent" (as quoted in Calvin Tomkins, *The Bride and the Bachelors* (New York: The Viking Press, 1968), p. 148).

38. Michel Sanouillet and Elmer Peterson, eds., *Salt Seller: The Writings of Marcel Duchamp* (New York: Oxford University Press, 1973), pp. 133-34.

39. Ray responded to the remark that "from 1915 to 1920, the home of Walter Arensberg in New York was the home of American Dada" by saying: "It wasn't Dada, it was a mixture of people who personally were sympathetic, and who thought that Arensberg's was a good place to meet people. It was a mixed salon" ("Interview with Man Ray," Schwarz, *New York Dada,* p. 94). Also, Alfred Kreymborg, a frequent visitor, recalled that Arensberg was "a profound classical scholar and reticent aesthete, he made each new movement his own, tried it a while and then dropped it: Symbolism, Vorticism, Cubism, Dadaism ... Arensberg was radical solely in theory" (as quoted by F. Kimball, "Cubism and the Arensbergs," *Art News Annual* 24 (1956), p. 121). The social character of the salon has been described by Gabrielle Buffet-Picabia as a place where "at any hour of the night one was sure of finding sandwiches, first-class chess players, and an atmosphere free from conventional prejudice" (as quoted in Motherwell, *Dada Painters,* p. 260).

40. Stieglitz Archives, Beinecke Library, Yale University. Emphasis added.

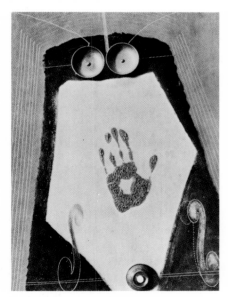

Man Ray (American, 1890-1976), *Self Portrait*, 1916, mixed media. Original lost, photograph by Man Ray. Collection of Juliet Man Ray, Paris. © 1985 Juliet Man Ray. (Copied from A. Schwarz, *Man Ray: The Rigour of the Imagination.*)

gallery. Picabia exhibited paintings, done in New York, more radical in nature than his work at the Armory.[36] Thus the Picabia exhibit was "291" thumbing its nose at the Armory Show, by taking the Armory's radicalness one step further.

Certain elements of so-called New York Dada continued the spirit of "291," and Duchamp's readymades, an all out negation of art, even surpassed it. De Zayas's abstract caricatures had been anti-art, but had been the product of artistic creation. Duchamp's readymades were not. Acting like a god, Duchamp had magically transformed a common object into a work of art simply by choosing it and calling it one. The readymade essentially negates the idea of art as the product of a special sensibility; it is an intellectual game, like chess, made visual. And like chess, it is indifferent to the "real" world.

Indifference was Duchamp's personal definition of Dada,[37] but Dada, though self-contradictory, was not indifferent. Duchamp's penchant for self-contradiction was an effort to avoid conforming to his own taste.[38] Therefore he did dada and non-dada things. As a whole, in their ambiguity New York Dada and the Arensberg salon were not Dada (the movement), and much less DADA, since public confrontation was hardly present, as both Duchamp and Man Ray themselves have declared.[39] New York Dada and the Arensberg salon formed the New York avant-garde, but while an aesthetic vanguard and iconoclastic in spirit they failed to be Dada, as their involvement was almost totally intellectual and not social or politically engaged.

For sociopolitical criticisms and actions by dadas in New York, one must turn to Benjamin de Casseres, the most outrageous and emotional of "291" rebels. De Casseres's tone had been relatively mild in a letter to Stieglitz around early 1910:

I received a letter from [Leonard Charles] van Noppen today in which he says he wishes he could persuade you to stand for the whole Secession movement—in art, literature and philosophy. If you gave van Noppen, Sadakichi [Hartmann], De Zayas, and myself full swing we could make **Camera Work** *the most famous magazine in the English speaking world. You may think this presumptuous, but you know that I am a born rebel. Rebellion is life.*[40]

"Hypocrisy in the guise of PROGRESS is a wonderful commodity in America today."

41. "Decadence and Mediocrity," *Camera Work* 32 (October 1910), p. 39. Emphasis added.

42. Stieglitz Archives, Beinecke Library, Yale University.

43. Letter to Benjamin de Casseres, dated 9 April 1913, Stieglitz Archives, Beinecke Library, Yale University. Emphasis added.

44. For an account of the Weimar period, see John Willett, *Art and Politics in the Weimar Period* (New York: Pantheon Books, 1978).

45. Among the sixties NO!s, the Doom artists depended on Ban the Bomb horrenda for their shocking assemblages, yet their work, probably because of their lack of individuality, fails to be effective. Cf. Lucy Lippard, *Pop Art* (New York: Frederick A. Praeger, 1966), p. 103.

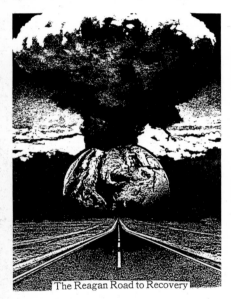

The Reagan Road to Recovery

San Francisco Poster Brigade, *The Reagan Road to Recovery*, c. 1984, photocopy, 8 1/2 x 11 in (21.6 x 27.9 cm). Courtesy of Ileana B. Leavens.

By October of that year, de Casseres's tone was more vehement. Like other dadas, he felt a spiritual kinship with Decadence, and wrote in *Camera Work:*

The decadent, the revolté: the man with a new vision, the new way, a finer perception, is always a danger to the community of dullards, to the sanctified hierarchy of saintly academicians and embalmed mediocrities.

Originality wears the mien of Catalina and brings not peace, but a sword. . . .

Morbid and pestilential? Yes! It threatens Stupidity with death and stands like a vision of Annihilation on the steps of the rotten rookeries of academic thought.[41]

Decadence had been a vision of annihilation; de Casseres put that vision into practice. He ran for the office of Mayor of New York in 1913, and his platform called for, among other things, the erection of the State of Manhattan, the legalization of gambling and houses of prostitution, the reopening of the race tracks, the enactment of a liquor law providing for the selling of liquor twenty-four hours a day, seven days a week (and this on the eve of Prohibition). It was a "recognition and legalization of human weakness," which neither grafters nor church-goers would vote for since, he said, they vote the same ticket: "Hypocrisy and graft are twin born."[42]

Stieglitz's response was up to par:

Hypocrisy in the guise of PROGRESS is a wonderful commodity in America today. It is on the free list; it needs no protection. It is the one real American product which seems to thrive everywhere in spite of tornadoes and floods, Roosevelts, Gaynors, not to forget all the ministers of the Gospel and all the teachers, and publishers and practically everybody else.

Here is to the Mayorship! I offer my services as the head of the Street Cleaning Department.[43]

In Germany, sociopolitical rebellion was literally taken to the streets by Berlin and Cologne Dada. From George Grosz's caricatures to John Heartfield's and Hannah Hoch's photomontages, Berlin Dadas widely displayed their virulent attacks against society and its politics.[44]

In Cologne, Dadas distributed 20,000 copies of the violently radical newspaper *Der Ventilator* to the workers. Its sale was suppressed by the British Army of Occupation. In America, where foreign occupation is virtually unknown, such large-scale confrontation flared up with the sixties sit-ins, freedom riders, race riots and the anti-Vietnam war demonstrations, in which thousands of posters showing murdered Vietnamese civilians were distributed.[45] At present rebellion has surfaced in the streets and within an art context, e.g., Jenny Holzer's *Sign on a Truck,* a mostly anti-Reagan display by 22 artists shown in the public squares of New York City on the eve of the 1984 elections (which, ironically, was partly funded by a state arts commission). In Seattle, a group called Working Artists for a Democratic Alternative placed ads in newspapers, put up posters and, most visibly, bought ad space on buses which took

46. During the Depression years, for example, American artists, who have not been distinguished for being involved politically, were.

47. See, for instance, Jim Emerson "RAMBO-mania: A national hero emerges from Nam 'defeat,'" *The Seattle Times*, 9 July 1985, D-1,4.

48. *The Last Time I Saw FERUS*, exh. cat., (Newport Beach, California: Newport Harbor Art Museum, 1976), n.p.

49. Interview with Hans Haacke by Catherine Lord, 24 June 1983, transcription by Douglas Kahn, pp. 14-15. I wish to thank Mr. Kahn for making the manuscript available to me.

50. Whether there was a direct relationship is unclear even to Haacke: "I have no idea whether that had anything to do with my *Taking Stock*" (Yves-Alain Bois, Douglas Crimp and Rosalind Krauss, "A Conversation with Hans Haacke," *October* 30 (Fall 1984), p. 44). See also, Jeanne Seigel, "Leon Golub/Hans Haacke: What Makes Art Political," *Arts Magazine* 58, no. 8 (April 1984), p. 112; Don Hawthorne, "Saatchi & Saatchi Go Public," *Art News* 84, no. 5 (May 1985), pp. 79-81; and Kenneth Baker, "The Saatchi Museum Opens," *Art in America* 73, no. 7 (July 1985), pp. 23-27.

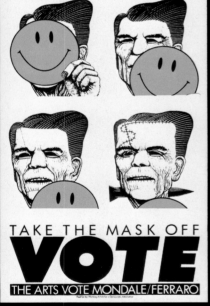

Working Artists for a Democratic Alternative, *Take the Mask Off: VOTE*, 1984, poster version, screenprint on paper, 23 1/4 x 15 1/4 in (59 x 38.7 cm). Courtesy of the artists.

their message all over town. Though these, like other contemporary NO!s, have failed to curb the present trends towards increasing conservatism, there is a continuing undercurrent of negation, which at times emerges into the open and becomes militant as in the Artists Call Against Intervention in Central America, anti-apartheid demonstrations, etc.

Militancy has in general appeared during periods of instability, such as the outbreak of a war, economic depression or political upheavals.[46] Militant movements do not usually emerge when society is experiencing relative tranquility and repose, qualities which have been constantly declining during this century. But even at those precious times, involved rebellion may appear: 1) as an individual reaction to the political, social or art establishments and their problems; 2) to a change in sensibility responding to a change in Zeitgeist; 3) in reply to a particular rebel whose magnetic personality attracts a number of followers.

At present, there are no leaders either in the political arena or the arts, no Tzara or Stieglitz with a coterie around him and no Cabaret Voltaire or "291." Modern art and the avant-garde have been assimilated into the mainstream, into the Post-Modern, but Post-Modern art is for the most part eclectic. There is no avant-garde and there are no centers of rebellion. Rebellion is at best individual. But individualism too has declined, a condition sadly manifested by, as of this writing, the heroic in America being exemplified by Hollywood's all brawn, neo-Nazi Rambo, a total fantasy who is advertised and applauded as a symbol of the "American Spirit"— even the President remarked him favorably.[47]

But, there are dadas. Among these is Edward Kienholz, who has been described as "an incredible individual, indomitable con-man, vigorous organizer; a man who was [in the late 1950s] attempting to 'see what could be done to shake up and change a number of status quo situations vis-a-vis "culture," a word which would cause [Kienholz] to reach for a gun if he heard it at the time.'"[48] In his work from that time to the present, Kienholz has criticized society, dealt with the plight of the old and the insane, with prostitution and other topics the public wants to ignore. In turn, Hans Haacke (another troublemaker), has made public the interconnections of the art and corporate power structures, as well as the relations of industries with South African apartheid policies.[49] In a recent piece made for his exhibit at the Tate Gallery, Haacke questioned the role and influence of a prominent collector, Charles Saatchi, who was a member of the steering committee of the Tate's Patrons of New Art. In February 1984, one month after the Haacke show opened, Saatchi resigned that position; he had resigned his trusteeship of the Whitechapel Gallery shortly before.[50] Haacke and Kienholz are among those involved artists who choose to work within an art context (galleries and museums) rather than on the streets, as do some others.

L.H.O.O.Q.

51. This was vividly demonstrated when one of my students cheerfully presented a one-hour lecture on three made-up artists, including one Grossly Canard, and not one out of 52 students had the courage to question him, though the lecture was peppered with many inordinate comments. Several even took notes. At a "higher" level in the art world, Roy Lichtenstein complained about the artist's inability to make something so outrageous that the public would not accept it. He made that comment in 1963! To the question of "What is Pop Art?" Lichtenstein replied: "I don't know—the use of commercial art as subject matter in painting, I suppose. It was hard to get a painting that was despicable enough so that no one would hang it—everybody was hanging everything. It was almost acceptable to hang a dripping paint rag, everybody was accustomed to this. The one thing everyone hated was commercial art; apparently they didn't hate that enough either" ("Roy Lichtenstein Interview with G.R. Swenson," in Pop Art Redefined, ed. John Russell and Suzi Gablik (New York: Praeger Publishers, 1970), p. 92).

52. Schamberg's piece is rather unusual for his oeuvre, and it has been claimed it was done in collaboration with the Baroness von Freytag-Loringhoven.

53. Anne d'Harnoncourt and Kynaston McShine, eds., Marcel Duchamp, exh. cat., (New York and Philadelphia: The Museum of Modern Art and The Philadelphia Museum of Art, 1973), p. 289.

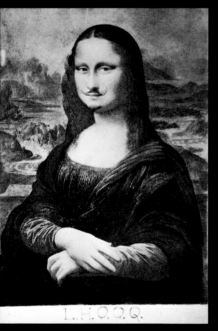

Marcel Duchamp (French, 1887-1968), L.H.O.O.Q., 1919, pencil on printed reproduction, 7 3/4 x 4 7/8 in (19.7 x 12.4 cm). Private Collection, Paris.

Involved artists thus confront two major kinds of audiences: the art world and the general public. While differing in make-up, both are held together by respect for, submission to or fear of authority—the establishment. These two groups hold different views on issues forming society's backbone: patriotism, honor, dignity, the family, religion, tradition and so forth, as well as differing in their receptivity to the work of artists. The general public's reaction to artists' NO!s, if provoked, is generally stronger than that of the art world, particularly as negativism and disorder have been increasingly incorporated—or coopted—into the mainstream. It is ironic that many of Dada's tools and weapons for protest have been turned into aesthetic techniques, especially since the 1950s, by an art system capable of assimilating and neutralizing even the most outrageous.[51]

Involved artists have targeted the public's sacred cows; they have questioned, openly criticized or blatantly ridiculed. The most virulent of these attacks have come from DADA, whose trickster character has provided superb weapons for confrontation. Thus Dada and dadas have resorted to irreverence, humor, tricks and insults in this never ending battle against tradition, including the tradition of the new.

Irreverence has been directed particularly against the most enshrined ideas and beliefs, of which religion and art are two of the most enduring. Classic among Dada's religious "blasphemies" are Picabia's *Blessed Virgin,* 1920, consisting simply of a black ink splotch, and the no less unholy *God,* 1918, by Morton Schamberg, probably the most Dada of all New York Dada products: a miter box supporting a piece of plumbing.[52] Edward Kienholz's *God Really Loves America the Best,* 1964, shares Schamberg's iconoclastic spirit. But DADA has reserved its more malicious attacks for ART.

Of ART's holy images, the Mona Lisa is probably the holiest. Thus it was a fair target for Duchamp, during one of his dada moods. Duchamp's *L.H.O.O.Q.,* 1919, consists of a reproduction of the Gioconda which Duchamp "rectified." Of this piece Duchamp said: *In 1919 I was back in Paris and the Dada movement had just made its first appearance there: Tristan Tzara who had arrived from Switzerland, where the movement had started in 1916, joined the group around André Breton in Paris. Picabia and I had already shown in America our sympathy for the Dadas.*

This Mona Lisa with a moustache and a goatee is a combination readymade and iconoclastic dadaism. The original, I mean the original readymade is a cheap chromo 8 x 5 on which I inscribed at the bottom four [sic] letters which pronounced like initials in French, made a very risqué joke on the Gioconda.[53]

(When pronounced quickly L.H.O.O.Q. reads, *"elle à chaud au cul,"* "she has a hot ass.")

Much more complex both in structure and content was Jean Tinguely's *Homage to New York,* 1960. It was the apotheosis of the sixties image of Dada: a huge contraption made out of junk, whose raison d'être was to self destruct. Although it had been programmed to do so, it failed and had to be finished off by the Fire Department, those overworked protectors of limb and property. But before its demise, the work managed to execute a great many unexpected and

54. According to Agnes Meyer, who had been connected with "291" since its inception, "pranks" were played on the public. The plural indicates that the Cézanne hoax was not the only "291" joke at the public expense. Cf. Leavens, From "291," p. 84.

55. For one of the versions, see Man Ray's account in Schwarz, New York Dada, p. 90.

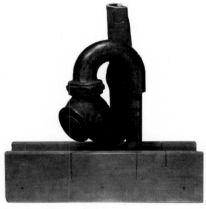

Morton L. Schamberg (American, 1881-1918), *God*, c. 1918, miter box and plumbing trap, 10 1/2 in (26.7 cm) high. Philadelphia Museum of Art, Louise and Walter Arensberg Collection.

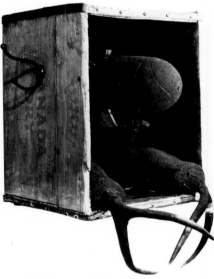

Edward Kienholz (American, b. 1927), *God Really Loves America the Best*, 1964, mixed media, 20 3/4 x 15 1/2 x 12 in (52.7 x 39.4 x 30.4 cm). The Louisiana Museum, Humlebaeke, Denmark (Photo: Walter Russell, Courtesy of the artist).

startling feats before a distinguished audience, gathered in the sacrosanct grounds of that preserver of artistic heritage, a museum of art. *Homage* was a travesty of the museum concept, of art as an object to be cherished and preserved, and an impudent gesture against the art establishment and the social, moneyed elite associated with it. The event also had a certain trickster-like quality, for the select audience was provided not with an artistic creation but with an artistic destruction.

Playing tricks on the public is not far behind irreverence in Dada's arsenal. At times, however, they have backfired. True to the Dada spirit the "291" group were pranksters.

Thus for the 1911 exhibition of Cézanne's watercolors at "291," Stieglitz and his group jokingly included a fake, painted by Edward Steichen, among the real ones, but it turned out to be the public's favorite."[54] While this time the public unwittingly won, for the most part the Dadas have had the last laugh, measuring their degree of success by the amount of violence they have extracted from their audiences. At times the confrontations have been highly amusing, as in Man Ray's *Self Portrait,* 1916, an assemblage surmounted by two bells, with the imprint of the artist's hand above a push button. When the viewer yielded to temptation and pushed it, the bells did not ring. Other Dada confrontations have become classics: the aptly famous 1917 "lecture" by Arthur Cravan at the Independent's Exhibition has been often retold, with a number of variations, in the literature on Dada. Aimed at a group of New York socialites interested in Modern Art, the lecture had been organized by Duchamp and Picabia, who had invited Cravan to be the speaker. Cravan arrived dead drunk—as he usually was—and, depending on which version you read, either began to undress or merely opened a valise and threw out his dirty linen, all the while hurling insults at the audience. The police soon carted him off to jail, from which Arensberg subsequently bailed him out.[55]

"Resolved: That the people who attend literary events are imbeciles."

56. Doug Fetherling, *The Five Lives of Ben Hecht* (Toronto: Lester and Orpen Limited, 1977), p. 62.

57. Stated by Duchamp in Greta Deses's film *Dada,* 1969 (dist., International Film Bureau).

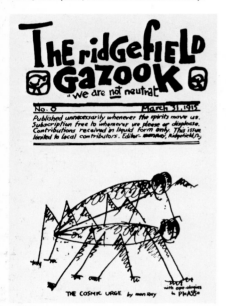

Man Ray (American, 1890-1976), *The Ridgefield Gazook,* page 1, 1915, photographic original prepared for reproduction. Collection of Arnold H. Crane, Chicago.

Man Ray (American, 1890-1976), *The Ridgefield Gazook,* page 3, 1915, photographic original prepared for reproduction. Collection of Arnold H. Crane, Chicago.

More provocative in character, and reminiscent of European Dada, was Ben Hecht's and Maxwell Bodenheim's appearance at a snobbish literary gathering in Chicago during the early twenties. They agreed to conduct a literary debate, on a topic to be announced that evening. For this they were paid the then considerable sum of $100.00. The debate was opened when Hecht dramatically intoned: "Resolved: That the people who attend literary events are imbeciles." After a prolonged silence he added, "I shall take the affirmative. The affirmative rests." Bodenheim, taking the negative, conceded: "I guess you win." The two beat their way out, 100 dollars richer.[56]

This "literary" event has been mostly forgotten. Dada in Chicago seems to have had no further repercussions, but Dada in New York did, for Duchamp's entry for the Independents Exhibition of 1917 caused a revolution in Modernist aesthetics and philosophy. Duchamp's contribution was *Fountain,* a urinal which he signed and dated "R. Mutt 1917." It was not the first of his readymades to be shown, but it was the most shocking, and the organizers excluded it from the exhibition. This reaction arose not from aesthetics (although aesthetics was to become the excuse), but on account of puritanical traditions, to which members of the Independents must have adhered. If the public was not involved, as Duchamp himself has said,[57] then it was a test of the Independents' "independence." However, Duchamp's trick lay in testing it outside the realm of aesthetics.

Yet, all these events pale when compared to the Cologne Dada exhibition of April 1921:

The site of the exhibition was picked deliberately. The center of Cologne was chosen as accessible to the public and its slander. Dada planned to insult, and to this end rented a little glassed-in court behind a cafe, which was reached through a public urinal: a wise precaution, with a certain number of visitors assured from the first—visitors or victims, it is hard to say. A young girl dressed for her first communion opened the exhibition. Did the blue posters designed by Ernst, showing simple doves and adorable cows cut out of primers, give a hint of what this exhibition, this demonstration, by young painters would be? I can just see the gullible visitors in search of an aesthetic experience. The prettiness of art is measured by the admission fee. And this exhibition was not free. The public, expecting art, is treated to outrages against tradition. And suddenly the little girl dressed for her first communion begins to recite obscene poems. . . .

58. Georges Hugnet, "The Dada Spirit in Painting," in Motherwell, *Dada Painters*, pp. 159-60. Emphasis added.

59. Leavens, *From "291,"* p. 144.

60. In the Bern Kunsthalle's exhibition catalogue, the table of contents lists "information" on Glass, and background information was included for artists who executed pieces specifically for the occasion. But, there is no writing in the "G" section. Glass, complete with exhibition and publication record, and archives in the non-existent New Gulf Museum in Portland, Oregon, appeared in the first but not in the second edition of *Contemporary Artists* (Colin Naylor and Genesis P-Orridge, eds. (New York: St. Martin's Press, 1977), pp. 342, 343). I do not know whether the "existence" of Glass was discovered or whether he was dropped because he had not been an important enough artist.

61. Hugo Ball, *Flight Out of Time: A Dada Diary* (New York: The Viking Press, 1974), p. 56. Emphasis added.

62. Quoted from Richard Huelsenbeck, *Memoirs of a Dada Drummer* (New York, The Viking Press, 1974), p. 52. Emphasis added.

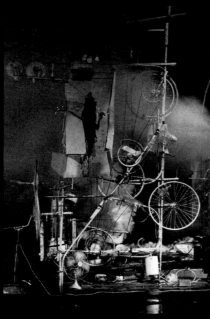

Jean Tinguely (Swiss, b. 1925), *Homage to New York*, 1960, mixed media assemblage in the act of self-destruction in the sculpture garden of the Museum of Modern Art, New York, 17 March 1960. (Photo: David Gahr).

Naturally when a beer-drinker, having downed the last drop whicl causes the vessel to overflow, went to the urinal and saw what was going on, the exhibition received some rough treatment: . . . to complete the triumph of Dada. A complaint against obscenity was lodged with the police. When the police arrived they discovered tha what had aroused the most indignation was an etching by Albrecht Durer, and the exhibition was re-opened.[58]

The antics of Duchamp, Ray, Stieglitz's "291," Hecht, and Cologn Dada are manifestations of Dada's humor in direct public confrontation. Humor has been also expressed in less public ways, as in Man Ray's publication *The Ridgefield Gazook,* 1915, which insulted the avant-garde and explained nothing; in the whimsical 1922 portrait of Marcel Duchamp by Elsa von Freytag-Loringhoven; in Picabia's toy monkey mounted on board and titled *Portrait of Cézanne, Portrait of Rembrandt, Portrait of Renoir, Still Lifes,* 1920; in Duchamp's *L.H.O.O.Q.*; and more recently in William Wegman's photographs of his dog, Man Ray. Humor was also the backbone of the Inje-Inje movement, whose Dada character has been aptly described by one of its members, Malcom Cowley:

Inje-Inje was a joke thought up by Holger [Eddie] Cahill. He pretended to be an anthropologist who had discovered in the Amazonian jungles a tribe so primitive that it had only two words in its language, "Inje-Inje," spoken with such differing intonations tha they expressed almost anything. On this he laughingly founded a new aesthetic. The joke was a Dada joke—but there was no school, except those like me who enjoyed the joke.[59]

That type of joke is still alive. Recently Ted Glass, a non-existing artist derived from Duchamp and Picabia whose name appeared in the catalogue for the 1969 exhibition "Live in Your Head: When Attitude Becomes Form," was duly included in *Contemporary Artists,* a reference book found in museums and libraries.[60]

No form of artistic creation, whether in literature, the visual arts, music or theater has managed to escape Dada's humor: Dada poetr has been made from the random choice of pre-cut words taken out a bag; a similar procedure was devised for music; a machine has painted pictures; theater became an unstructured and irreverent performance; and found objects or their photographs were humorously transformed via a title, such as Picabia's *Ane* or Man Ray's *Man.*

But DADA has worn a double faced mask: it has been "buffooner and a requiem mass."[61]

In those words Hugo Ball described the Cabaret Voltaire; they als: can be applied to Dada in Cologne and Berlin. Unlike that of the Stieglitz circle, "New York Dada" had been just buffoonery. The American rebellion in the 1960s was a requiem mass.

The reawakening of the Dada spirit in the sixties was, like the original Dada, "a revolt against imminent leveling, stupidity, destruction. . . . The distress cry of creative people against banality."[62] At a time when Modernism had become an academy anc the avant-garde was dead, Dada's weapons—the gesture, the event—were resurrected and society's own products (found objects) and her means of communications (the media) were once

. *Defoliation* was part of a group exhibition led "The 80s" (catalogue titled *Free*). See obin White, "An Interview with Terry Fox," in *he Art of Performance: A Critical Anthology,* . Gregory Battcock and Robert Nickas (New ork: E. P. Dutton, 1984), pp. 208-09; Carl effler, *Performance Anthology: Source Book r a Decade of California Performance Art* (San ancisco: Contemporary Arts Press, 1980), . 16, 17.

. The concept of a mirror as a sign of death s had a long art historical tradition from at ast the 15th c. to Picasso. But in Burden's eces, the artist himself became the mirror; us a living being had taken the place of a etaphor, and thereby transformed the ctorial image into reality.

. Willy Rotzler, "Messages—Coded by Ed enholz," in *Edward Kienholz: olksempfängers*, exh. cat., (Berlin: ationalgalerie Berlin, 1977), pp. 8-9.

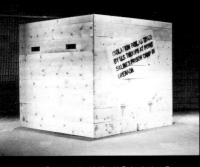

ns Haacke (German, b. 1946), *U.S. Isolation Box, renada, 1983*, 1984, wood and metal, 8 x 8 x 8 ft (2.4 x x 2.4 m). Owned by the artist (Photo: Courtesy of the tist).
enciled on the side: "ISOLATION BOX, AS USED BY S. TROOPS AT POINT SALINES PRISON CAMP IN RENADA"
rst exhibited at the Artists' Call Against U.S. tervention in Central America exhibit, City University New York campus, January 1984.

more flung back in her face. But in America the times, like the men, had changed. Negation in the sixties was stronger; at times it was literally nihilistic, like Terry Fox's 1969 performance, *Defoliation,* in the garden of the University Art Museum on the Berkeley campus. It consisted in cremating a large number of jasmine plants with a flamethrower to protest the war in Vietnam and provide "the wealthy people who regularly enjoyed the garden with a concrete example of the type of action they supported with their dollars and their complacency."[63]

Nihilism in art has varied greatly, as it depends on what the artist and his audience perceive as being destructible or sacred. To the well-fed bourgeois who frequented the Cabaret Voltaire, the singing, dancing and poetry reading had appeared as "idiotic" nonsense. It was harmless "fun." War-torn Cologne was different from peaceful Zurich. There rebellion took to the streets; for the English authorities *Der Ventilator* was a threat, and was confiscated. The jasmine plants were no threat, but could serve as symbols for America's complicity and were therefore destroyed. But *Defoliation* was more than an anti-war piece. Crossing the threshold between art and life, Fox held up a mirror of reality to the public, and forced it to face the very basic issue which Americans want to ignore: the actuality of death. *Memento mori* as well as illness and old age have been acceptable subjects in ART. There they have been visual metaphors of life's decline, compressed within the two-dimensionality of the picture surface or represented in sculpture. The viewer stands at a psychological distance because the images pertain to the world of art, not to actuality. But Dada uses all of reality, and transforms it into another, more powerful and direct verity that the audience is forced to enter and of which it becomes part.

To underline that power and directness, the artist at times has put himself in dangerous situations. Chris Burden, for example, has actualized the notions of life and death, face to face with his audience. Burden's performances have been powerful Gestalt figurations in which the artist, placing himself in jeopardy, underlined life's fragility and thus became a mirror of mankind.[64] Edward and Nancy Reddin Kienholz's *Still Live,* 1974, as shown in Berlin was actually dangerous—potentially lethal—to the audience, and authorities removed it from the exhibition.[65]

Dadas have also challenged the public's and society's sense of morality, by forcing the viewer to become accessory after the fact. Thus in Kienholz's *Back Seat Dodge '38,* 1964, a mirror implicates the spectator as a voyeur in a private act made public. A mirror in Edward and Nancy Reddin Kienholz's *Portrait of a Mother with Past Affixed Also,* 1980-81, places the viewer in direct confrontation with his or her own aging and ultimate death. Fox's *Defoliation* and Hans Haacke's exact replica of the isolation boxes used by the United States in Grenada literally confronted the viewer with questionable acts done by Americans. Both caused scandals and Haacke's work in particular struck a raw nerve. It was offensive enough to American idealism that it was denounced as fiction by the conservative press, and was shunted into the darkest corner possible during an exhibition devoted, of all things, to protest United

Performances and exhibitions in museums and galleries can affect only a small number of individuals; mass-oriented means of confrontation are needed to involve the public at large.

66. Quoted in Bois, Crimp and Krauss, "A Conversation with Hans Haacke," p. 35. See Seigel, "Leon Golub/Hans Haacke," p. 113, for information on the exhibition. The incident recalls the similar fate of Duchamp's *Fountain*; Haacke too leaves to the viewer the onus of defining the shock level of the piece.

67. For example, the Neo-Classical style was modified to serve the purposes of the French Revolution; its subsequent adoption and into naturalistic kitsch has been useful in Communist Russia and Nazi Germany; the People's Republic of China turned to Western traditions for its propaganda art, while post-1960 Cuba has placed art at the service of the Revolution. For art and the French Revolution, see Ronald Paulson, *Representation of Revolution* (New Haven: Yale University Press, 1983), pp.1-36; for the Russian revolution, see David King and Cathy Porter, *Images of Revolution: Graphic Art From 1905 Russia* (New York: Pantheon Books, 1983).

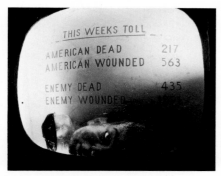

Edward Kienholz (American, b. 1927), *The Eleventh Hour Final (detail)*, mixed media, 8 x 12 x 14 ft (2.4 x 3.7 x 4.3 m), Collection of Reinhard Onnasch, Berlin (Photo: Courtesy of the artist).

States intervention in Latin America! Haacke: "I used dada strategies—the readymade, challenge to cultural norms, and so on. . . . [I]t was the political specificity that caused the amazing hoopla around the piece. I thought it would take more to get the *Wall Street Journal* to foam at the mouth and commit three factual errors in one editorial."[66]

But performances and exhibitions in museums and galleries can only affect a small number of individuals; mass-oriented means of confrontation are needed to involve the public at large: thus the media with their inherently public nature have been very effective Dada weapons.

Mass communications (a double-edged sword) are still primarily used as means of political, religious or artistic propaganda. Whether of the right or the left, political authorities have resorted to mass-produced and mass-oriented art.[67] Since at least the time of Durer multiply produced images have been used effectively to manipulate the public's needs and tastes, a function now expanded exponentially through advertisements—or even the news—in magazines and newspapers, on radio and TV. The media determines what the public sees, learns and believes, providing a world view dictated by what is publicized, which many times has been the very opposite of actuality. The media also becomes considerably more compelling as the visual images gain predominance, because of their immediacy and their evidential value. Dadas have used each of the progressively more sophisticated displays of mass media, from photomontage to video, and turned them into vehicles for furious NO!s.

Photomontage was born during the Weimar Republic; it reappeared ten-odd years later as a weapon against Nazi inhumanity and the probability of a second World War. Photomontage is still a hot means of negation. At a time when mankind faces the possibility of a nuclear holocaust, one find anti-government, anti-war, anti-authority posters and handbills posted in public places and in print.

Since the Weimar Republic communications have changed drastically, but their ability to seduce the masses into a soporific tolerance of the intolerable has not changed. Dadas have seen and reacted to this danger. Thus the Kienholzes' *Volksempfängers,* 1975-77, were aimed at Germany's blind acceptance of Nazi propaganda, and, closer to home, Kienholz's *The Eleventh Hour Final,* 1968, questioned the morality of the war and the role of the TV that brought Vietnam's body count right into the living room.

Entertainment and shock are connected: as an ever increasing level of shock is accepted, stronger stimuli are needed to sustain the audience's interest.

68. For a bibliography of reactions and of Haacke's and Thomas Messer's published statements, see *Hans Haacke: Framed and Being Framed, 7 Works 1970-75* (Halifax: The Press of Nova Scotia College of Art and Design, 1975), p. 113. Haacke has also provoked a response with articles he has published in art journals, e.g., see his "Working Conditions," *Artforum* 19, no. 10 (Summer 1981), pp. 56-61, and the Letters in the following issue, *Artforum* 20, no. 1 (September 1981), p. 2.

69. Hugo Ball noted in his diary: "Our attempt to entertain the audience with artistic things forces us in an exciting and instructive way to be necessarily live, new, and naive. It is a race with the expectations of the audience, and this race calls on all our forces of invention and debate" (Leavens, *From "291,"* p. 105).

70. Even after the Guggenheim incident, Haacke continued to be invited to participate in exhibitions in European museums. Haacke has explained the differences in reaction between European and American museums this way: "European museums are structured differently, they have different kinds of boards of trustees. They are public institutions, the people who work there are civil servants, usually with tenure. Therefore, if they were to do something that would not sit too well with the supervisory bodies, they are not putting their job on the line" (Haacke/Lord interview, p. 3).

Hans Haacke (German, b. 1946), *Taking Stock (unfinished)*, 1983-84, oil on canvas, wood, gold-leafed frame, 95 x 81 x 7 in (241.3 x 205.7 x 17.8 cm). Collection of Gilbert and Lila Sullivan (Photo: Zindman/Fremont, Courtesy of John Weber Gallery).

Kienholz attacked the media's ability to influence; Haacke has used the press itself to show the separation of the spheres of art and life in America. One of the most famous of Haacke's early provocations was *Shapolsky et al Manhattan Real Estate Holdings, A Real-Time Social System as of October 1, 1971.* The piece, proposed for exhibition at the Guggenheim Museum, consisted of a listing of property holders in Manhattan, with photographs of slum and middle class real estate. Although it revealed the interlocking character of ownership and implicated some church groups as slumlords, it did not implicate anyone connected with the Guggenheim; yet the piece was rejected. Though it was not shown, the related correspondence between Haacke and the museum's Director was made public by the artist, and articles, guest editorials and letters to the editor by the parties involved appeared in art journals. The piece was thus extended to include the art world and its reaction: a brief boycott of the Museum by leading avant-garde artists.[68]

But as the artist's weapons have evolved, so has the audience's resilience and resistance to them: the artist's ability to shock is in decline. Even within the short life span of the Cabaret Voltaire, Zurich Dadas were forced to use greater and greater ingenuity to entertain the audience.[69] Entertainment and shock are connected: as an ever increasing level of shock is accepted, stronger stimuli are needed to sustain the audience's interest.

In the world of art and aesthetics, Modernism provided that stimulant to traditional art; the avant-garde played a similar role within Modernism proper, and finally Dada's anti-art became the strongest of all shocks. But each of these NO!s has been assimilated in turn; anti-art has become art, exhibited in and commissioned by museums. Even Haacke's controversial work, after several years of being shunned by American museums, is at present gradually finding its way into North American museum collections.[70]

These changes in what is acceptable in the art world have echoed similar changes in the "real" world. Both have been shaped by revolts and liberation movements; they have been influenced by the media, and have faced outbursts of rebellion as a way of life. These have induced an ever increasing acceptance of the previously unacceptable: the Flapper exposed her knees; nudity or at least semi-nudity were a trademark of the "streakers" in the seventies, as well as of contemporary cinema and theater. The Flapper promoted cursing and sexual freedom in polite society; these have by now become acceptable, in life and in art. Other kinds of group negation have periodically appeared: the beatniks, hippies and punks, for example. Each of these however, has betrayed individuality in preference or submission to a group image; they have been the rebellious counterpart to acceptable equalization.

This equalization, which has become a trend in contemporary America, may be due to a misinterpreted concept of democracy, as well as the impact of systems of communications that cater to the lowest common denominator, and introduce a negativism which is the most revolting for being the most accepted. The news media for example, has eradicated the differences of what is private from what is public; the viewer in effect becomes a voyeur, a situation believed

71. Llyn Foulkes, *Llyn Foulkes: Fifty Paintings, Collages and Prints from Southern California Collections*, exh. cat., (Newport Beach: Newport Harbor Art Museum, 1974), n.p.

72. As an art movement, Dada worked within a small section of society: in Zurich at the Cabaret Voltaire and in Paris through theatrical performances. As a mass-oriented movement, in Cologne and Berlin, Dada did confront a large public. But the times were too chaotic for Dada to become more than just another revolt in a period of continuous insurrections. Yet, Dada must have made an impact in German consciousness, as Adolf Hitler was compelled to single it out for virulent attack in *Mein Kampf* and later speeches.

73. As quoted in Howard Smagula, *Currents: Contemporary Directions in the Visual Arts* (Englewood Cliffs, N.J.: Prentice-Hall, 1983), p. 263.

perfectly tolerable with respect to the news (since it is of "human interest"), but not as admissible in an art milieu. It also emphasizes the most brutal aspects of American society. Llyn Foulkes's work has reflected on the media's penchant for horror. In a 1974 interview he said: "The new work is a statement about the horror in the news—the Manson killings, assassinations, etc."[71]

The media, and especially television, have succeeded where Dada for the most part failed, namely in becoming a mirror of reality.[72] But it is a mirror that presents a numbing image, not one that leads to action. Perhaps the ultimate is rock video, which has introduced extreme forms of negation and irreverence right into the living room.

In response to the current situation Haacke has defined the contemporary artist's role thusly:

The artist's business requires an involvement in practically everything. . . . it would be bypassing the issue to say that the artist's business is how to work with this and that material or manipulate the findings of perceptual psychology, and that the rest should be left to other professions. . . . The total scope of information he receives day after day is of concern. An artist is not an isolated system. In order to survive he has to continuously interact with the world around him. . . . Theoretically there are no limits to his involvement[73]

Considering the high degree of negativism present in society, and the fact that it continues to grow; considering that at present the increasingly homogeneous public hardly finds anything shocking, whether in content or form, who in the future will be that thinking individual able to stand up and speak like the Dadas and their followers did, not for a particular society but for mankind? In what way will he be heard? How will he shout his **No!!!?**

1946
Chris Burden born on April 11, in Boston, Massachusetts, to Rhoda and Robert Burden. Grows up in France and northern Italy, attends a Swiss boarding school until returning to Cambridge, Massachusetts, for high school.

1969
B. A., Pomona College, Pomona, California.

1971
M.F.A., University of California, Irvine, California. For thesis is locked in a 2 x 2 x 3 foot locker for five days.
Prelude to 220 or 110 (F-Space, Santa Ana). Burden was strapped to the floor with copper bands bolted into the concrete. Placed near him were two buckets of water with wires carrying 110 volt currents submerged in them. Visitors could kick them over and electrocute Burden if they chose to.

1972
Lives and has studio in Venice, California (1972-1983).
Bed Piece (Market Street, Venice, California). A bed was placed in the middle of an all white room. On February 18, Burden took off his clothes, got in bed, and stayed until March 10, speaking to no one.
Dos Equis (midnight, October 16). Two X's constructed of 16-foot beams soaked in gasoline were placed upright blocking both lanes of a deserted stretch of Laguna Canyon Road and set on fire for whoever happened by.

1973
Through the Night Softly (Main Street, Los Angeles, September 12). Burden crawls through 50 feet of broken glass, wearing only shorts, holding his hands behind his back. Very few spectators.
Doorway to Heaven (November 15). Standing in the doorway of his Venice studio, Burden pushed two live electric wires into his chest. The wires crossed and exploded, shorting out.

1974
Trans-Fixed (April 23). Inside a small garage on Speedway Avenue, Venice, Burden stood on the rear bumper of a Volkswagen beetle and stretched his arms over the roof. Nails were driven through his palms into the roof, the garage door opened, and the car pushed to the street, where the engine ran at full speed for two minutes. The car was then pushed back into the garage and the door closed.

1975
White Light/White Heat (Ronald Feldman Fine Arts, New York). Burden stayed on a platform constructed high above the floor in a corner of the gallery for the duration of the show, February 8-March 1. The shelf was too high for visitors to see if he really was there, and many thought it was simply a California white-room, light and space piece.
Poem for L.A. A "TV commercial" broadcast in Los Angeles, consisting of three statements: "Science Has Failed," "Heat is Life," and "Time Kills."
B-Car. Burden designs and constructs a fully operative, 200-pound automobile, capable of 50 miles per hour, 150 miles per gallon. Drives from Amsterdam to Paris.

1976
Chris Burden Promo. TV commercial broadcast in New York and Los Angeles. Graphic presentation with voice-over of the names "Leonardo da Vinci, Michaelangelo, Rembrandt, Van Gogh, Picasso, Chris Burden" followed with "Brought to you by Chris Burden." (He realized if he had enough money, he could air this continually until his name would be added to the list of the world's most famous artists in polls of the American public.)

1979
The Reason for the Neutron Bomb. 50,000 matches laid on 50,000 nickels are arrayed in rows like toy soldiers, "a symbolic representation of the 50,000 strong Russian tank force which threatens Western Europe." On the wall is a statement that the U.S. military cites an East-West disparity in conventional arms as the reason for the neutron bomb's existence.
The Big Wheel, sculpture employing a three-ton, eight-foot diameter, cast-iron flywheel.

1980
Warning! Relax or You Will Be Nuked Again (ArtHouse, Nishinomiya, Japan). Sitting in cross-legged and wearing a World War II Japanese soldier's prayer flag like a veil, Burden interviewed 70 Japanese. Questions included: Why did the Japanese attack Pearl Harbor? Would you buy an automobile made in South Korea? Do Japanese men do the dishes?

1981
Diamonds are Forever (Ikon Gallery, Birmingham, England). A one-carat diamond suspended in a 3,000 square-foot black space, lit with a tiny pin spot.
A Tale of Two Cities (Los Angeles County Museum of Art). A large tableau with one miniature city's toy soldiers, tanks, airplanes, robots, making their way across the metaphorical midlands of the U.S. toward a similar assemblage defending another metropolis. Complete with binoculars so the visitor can play field marshall.

1983
Scale Model of the Solar System. The sun, represented by a ball the size of a basketball, was placed in a gallery of the Contemporary Arts Center, New Orleans. Mercury was placed in the next room, and so on, exactly to scale. Earth was in a Volvo dealership down the street.

1984
Moves to isolated part of Topanga Canyon, N.W. L.A.
Beam Drop. (Artpark, Lewiston, New York).

1985
Tower of Power (Wadsworth Atheneum). 1.2 million dollars worth of gold ingots stacked in a circle.

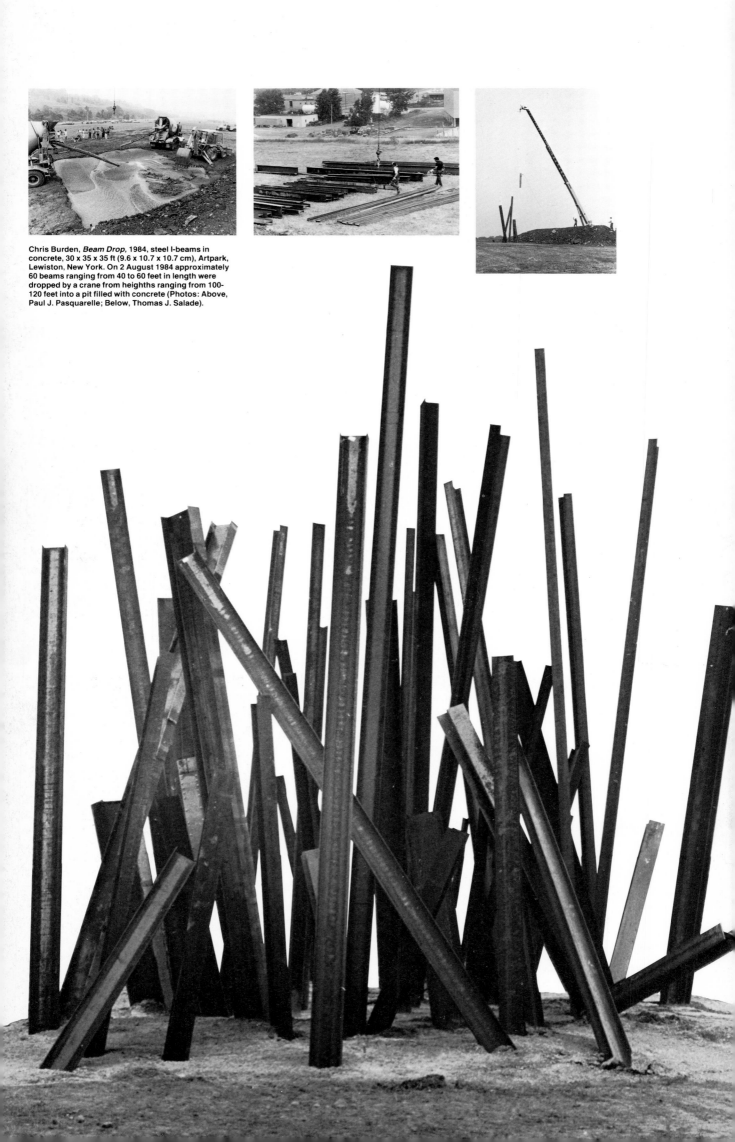

"I wanted to take these fascist materials that are used to build all the big fascist buildings and play with them, sort of like Jackson Pollock with I-beams."

Chris Burden, July 1985

Chris Burden, *Beam Drop*, 1984, steel I-beams in concrete, 30 x 35 x 35 ft (9.6 x 10.7 x 10.7 cm), Artpark, Lewiston, New York. On 2 August 1984 approximately 60 beams ranging from 40 to 60 feet in length were dropped by a crane from heights ranging from 100-120 feet into a pit filled with concrete (Photos: Above, Paul J. Pasquarelle; Below, Thomas J. Salade).

On the Early Performances:
"There were a number of us, like Terry Fox and Vito Acconci, who wanted to reassert how *serious* art was. There were these artists whose work was going from $1,000 to $10,000 to $50,000 in just a couple of years. That's not what art is all about."

Chris Burden, July 1985

Chris Burden, *Transfixed,* 23 April 1974, Venice, California (Photo: Charles Hill, Courtesy Ronald Feldman Fine Arts, New York).
"Inside a small garage on Speedway Avenue, I stood on the rear bumper of a Volkswagen. I lay on my back over the rear section of the car, stretching my arms onto the roof. Nails were driven through my palms into the roof of the car. The garage door was opened and the car was pushed half-way out into Speedway. Screaming for me, the engine was run at full speed for two minutes. After two minutes, the engine was turned off and the car pushed back into the garage. The door was closed."

Chris Burden, *Doorway to Heaven,* 15 November 1973, Venice, California (Photo: Charles Hill, Courtesy Ronald Feldman Fine Arts, New York).
"At 6 p.m. I stood in the doorway of my studio facing the Venice boardwalk. A few spectators watched as I pushed two live electric wires into my chest. The wires crossed and exploded, burning me but saving me from electrocution."

Chris Burden, *Tower of Power,* 1985, Wadsworth Atheneum, Hartford, Connecticut (Photo: Roger Dollarhide).
100 one-kilo bars of pure gold, having a value of 1.2 million dollars, were borrowed for the duration of the exhibition (January 12–20). Around the base of the stack were a number of matchstick figures in various postures, some kneeling before the tower.

"My art is an examination of reality. By setting up aberrant situations, my art functions on a higher reality, in a different state. . . . I think my art is an *inquiry,* which is what *all* art is about."

Chris Burden, 1974

Chris Burden, *In Venice Money Grows on Trees,* 6 October 1978, Venice, California (Photo: Courtesy of the artist).
"Just before sunrise two friends and I glued 100 brand new one dollar bills to the leaves of two very low palm trees on the Venice boardwalk. The bills were folded lengthwise several times so that they fit into the creases on each palm leaf. Although in plain sight and within arms' reach, some of the money remained untouched for two days."

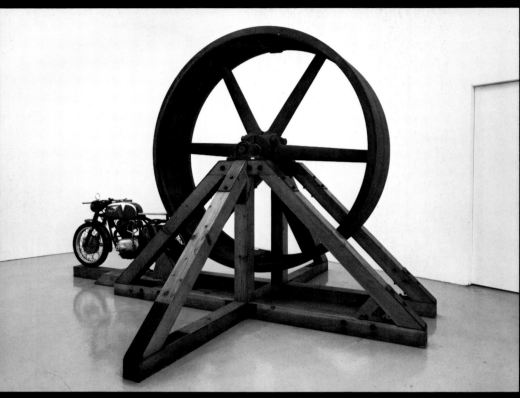

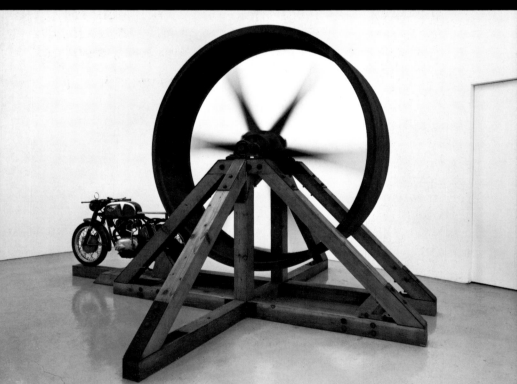

Chris Burden, *The Big Wheel*, 1979, 8 ft diameter cast-iron fly wheel, trestle of 6 x 6 in timbers, 250 cc Bellini motorcycle (Photos: Grant Taylor).

The three-ton flywheel is set in motion by the rear wheel of the motorcycle, which is started and run through its gears until maximum speed is reached, after which it is disengaged from the big wheel. Spinning silently at approximately 200 r.p.m., the flywheel has enough kinetic energy to turn for about 2 1/2 hours before coming to a rest.

"Art doesn't have a purpose. It's a free spot in society, where you can do anything. I don't think my pieces provide answers, they just ask questions."

Chris Burden, 1974

Chris Burden *White Light/White Heat*, 8 February–
1 March 1975, Ronald Feldman Fine Arts, New York
(Photo: Courtesy of the artist).
Burden stayed on a platform constructed high above
the floor in a corner of the gallery for the duration of the
show. The shelf was too high for him to be seen from
anywhere in the room.

Profile

Llyn Foulkes

1934
Llyn Foulkes born on November 17 to Helen and Raymond Foulkes, Yakima, Washington. Father leaves the following year; Llyn is raised by mother and grandparents.

1943
Hears Spike Jones record, becomes interested in music, begins playing percussion.

1949
Sees reproductions of paintings by Salvador Dali, interest in art jells.

1953-54
Attends University of Washington, Seattle, and Central Washington College, Ellensburg.

1954-56
Drafted into Army, stationed in Germany; travels in Europe and North Africa, visits numerous museums. Decides to attend art school.

1957
After discharge, settles in Los Angeles.

1957-59
Attends Chouinard Art Institute. Fellow students include Larry Bell, Joe Goode and Ed Ruscha. Foulkes becomes aware of the tradition and art of painting; is especially attracted to de Kooning's figurative work. Leaves school to pursue his own art.

1959
Walter Hopps selects Foulkes's work for inclusion in group show at Ferus Gallery, Los Angeles.

1960
Marries a fellow student from Chouinard. *Medical Box* contains painting of a figure with blood running down head and a red cross symbol, a precursor of later work.

1961
One-person show at Ferus Gallery over protests of gallery artists. By this time Hopps and Edward Kienholz had left the Gallery, and Foulkes's strong imagery placed it outside the range of work then being shown there.

1961-65
During this time, drives a taxicab and does production-line work in a hand-painted picture factory to support self.

1962
Individual exhibition at Pasadena Art Museum, includes blackboard paintings. Foulkes moves to Eagle Rock section of Los Angeles (through 1978); cow and rock paintings influenced by his seeing the Rock as a cow's skull one day while driving by.

1963
Joins Rolf Nelson Gallery, which shows George Herms, H.C. Westermann, Joe Goode, Judy Chicago, and Jess Collins. Begins series of postcard and rock paintings around this time.

1965
Begins teaching at U.C.L.A. (through 1971). Has continued to teach in Los Angeles area with exception of 1977-81: "teaching keeps me questioning myself."

1966-72
Plays drums in rock bands on Sunset Strip and around L.A., at a time of intense musical activity (The Doors, The Byrds, etc.) and upheaval between the establishment and the young, including police confrontations.
Continues rock paintings as an image of security and stability.

1969
Divorced, enters therapy.

1970
One-person show of rock paintings at Galerie Darthea Speyer, Paris.

1971
Marries Kati Breckenridge, a psychologist.

1972
Who's on Third, one of the first bloody head paintings.

1972-74
Quits rock band. Forms The Rubber Band in 1973, returning to his roots in Spike Jones and jazz; Rubber Band performs on the Tonight Show in 1974.

1974
Show of bloody heads at David Stuart Gallery, Los Angeles.
Survey of 1959-74 work at Newport Harbor Art Museum.

1976
First overtly "social painting," *Money in the Bank,* using image of Vice President Agnew.

1977
Rubber Band disbands; Foulkes begins work on "Foulkes-a-fone," a one-man band instrument.
Guggenheim Fellowship.
Begins building house in Topanga Canyon.

1978
Retrospective held at Museum of Contemporary Art, Chicago.

1979
Family moves into Topanga Canyon house; after accident while working on roof of studio and then studio's flooding, Foulkes temporarily stops painting in favor of music.

1982
Returns to painting full time.

1983
First show in Los Angeles in 10 years, at Asher/Faure, received enthusiastically by younger artists, most of whom are not familiar with his work.

1984
Tableaux such as *The Last Outpost* and *O Pablo* enlarge upon narrative elements.

1985
Almost dies from brain aneurism. Renewed commitment to social commentary— he terms the work "social expressionism."

"I think the artist must show everything and people can take it or leave it."

Llyn Foulkes, 1974

Llyn Foulkes, *One for the Money*, 1976, mixed media, 48 1/4 x 28 1/2 in (122.6 x 72.4 cm). Collection of Mr. and Mrs. Robert Sarkis, Seattle (Photo: Steven J. Young).

Llyn Foulkes, *Geometry Teacher No. 2*, 1974, mixed media, 41 3/4 x 31 3/4 in (106 x 80.6 cm). Private Collection, Chicago.

"His paintings are not pictures of revulsion, but revulsion itself."

Clark Polak, June 1974

Llyn Foulkes, *The Last Outpost*, 1983, mixed media construction, 81 x 108 x 5 in (205.7 x 274.3 x 12.7 cm). Courtesy of the artist and Asher/Faure, Los Angeles.

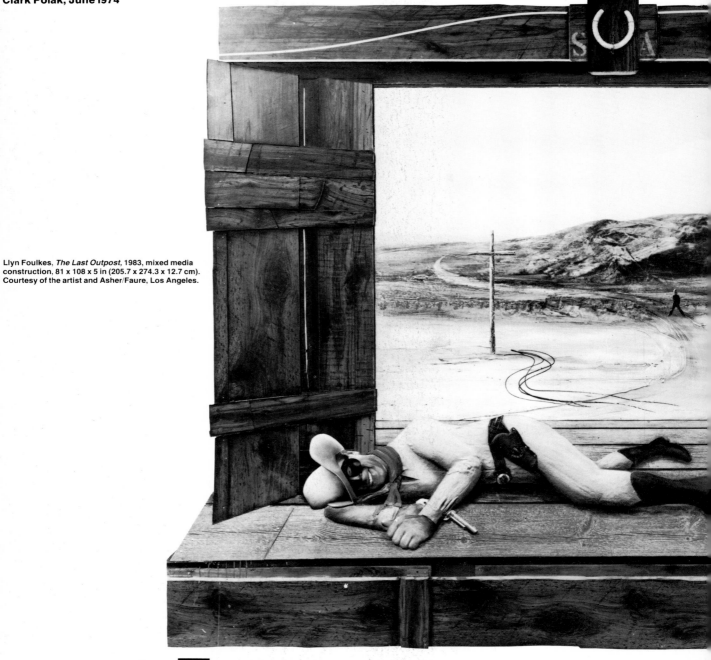

indifference is the one reaction that this incredible display rules out."

Henry J. Seldis, April 1974

"My last show was one of my best but L.A. is always so damn conservative they wouldn't buy it. I guess guts is a hard thing to sell."

Llyn Foulkes, 1984

"Foulkes maintains our interest by not being too professional. Each picture seems to have been put together with the awkwardness of fervid honesty telling us something dreadful is happening. They are perfect expressions of erupting anxiety."

William Wilson, October 1974

Llyn Foulkes, detail from a 1969 rock painting (Photo: Leni Iselin).

1936
Hans Christoph Haacke born on August 12 to Carl and Antonie Haacke, Cologne, Germany. Grows up in Cologne and suburb of Bonn. Parents are anti-Nazi; father loses job with City of Cologne for refusing to join Nazi Party.

1960
Equivalent of M.F.A. degree from Staatliche Werkakademie, (State Academy of Fine Art), Kassel, Federal Republic of Germany.

1960-61
Spends a year in Paris at Hayter's Atelier 17 on a DAAD grant and a year in Philadelphia at Tyler School of Fine Art, Temple University, on a Fulbright. Work of this period related to Group Zero artists.

1965
Moves with wife, Linda, an American, from Germany to New York, where they have lived since; Hans retains his German citizenship. Becomes interested in general systems theory; works incorporate such natural systems as water condensation, growing grass, documentation of seagulls feeding.

1967
Begins teaching art at Cooper Union, New York, where he is now Professor.

1968
While always conversant with current events and politics, around this time events like the murder of Martin Luther King prompt Haacke's increasing awareness that "the production and talk about sculpture have no relation to the urgent problems of our society."

1969
In protest of Brazilian government policies and their tacit U.S. support, Haacke pulls works to be sent by U.S.I.A. to São Paulo Bienal. Involvement with Art Workers Coalition, an activist group for artists' rights. Begins making works on social systems, including *Gallery Goer's Birthplace and Residence Profile, Part 1* and *News,* the placing of one or more news wire service teletype machines in museum exhibitions. Most works around this time rely on bare-bones "conceptual art" style presentation of information.

1970
MoMA Poll, concerning that year's New York State gubernatorial election, included in "Information" show at Museum of Modern Art, New York.

1971
Director of Guggenheim Museum cancels Haacke's one-artist show because of two works on Manhattan real estate holdings in social systems category (although physical and biological systems works approved). Curator is asked to resign. Haacke's release of relevant documents to press and subsequent responses generate heated discussion about censorship and division of art world and social world. Haacke's work is not included in a New York museum exhibition again until 1984.

1972
Krefield Sewage Triptych and *Rhine Water Purification Plant,* showing interaction of social and biological systems, shown Museum Haus Lange, Krefield, Germany.

1974
Solomon R. Guggenheim Board of Trustees shows links between trustees and Kennecott Copper, questions Kennecott's role in Chile.
Manet-PROJEKT '74, detailing provenance of Manet painting in Wallraf-Richartz Museum, Cologne, is rejected from exhibit co-sponsored by museum; a facsimile presentation by another artist is censored.

1975-76
Several works made exposing American multinational corporations' use of art and cultural patronage for public relations purposes and tax advantages (presented with corporate graphic image): *On Social Grease, Mobilization, The Goodwill Umbrella, The Road to Profits is Paved with Culture,* and *The Chase Advantage.*

1978-79
But I think you question my motives documents South African investments and dealings of Holland-based Philips corporation.

1981
The Chocolate Master juxtaposes information on the art collecting and patronage of Dr. Peter Ludwig with information on labor conditions in the candy factories of his West German-based company Leonard Monheim, AG.

1982
Oil Painting: Homage to Marcel Broodthaers, consisting of oil portrait of President Reagan in museum-style presentation opposite a photomural of peace demonstration.

1983
Voici Alcan publicizes this Canadian company's dealings in South Africa.

1984
U.S. Isolation Box, Grenada, 1984, a replica based on eye-witness accounts, is denounced by *Wall Street Journal* as a complete fabrication.
Haacke's individual exhibition at London's Tate Gallery includes painting *Taking Stock,* concerning business and art connections of Charles Saatchi. Mobil Oil Corporation's complaint to Tate Gallery and Stedilijk Museum, Amsterdam, prompts them to cease distribution of co-published catalogue including two of Haacke's works on Mobil.

1985
MetroMobiltan investigates relationship of multinationals' foreign ventures, their cultural patronage, and museums' courting of the latter.

 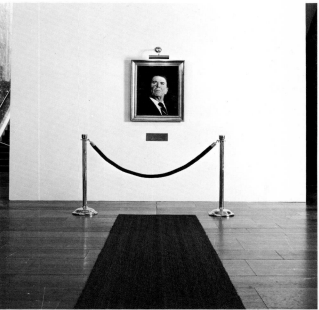

"It is true that I often play on the modes of the contemporary art world; and I try to make something that is accessible to a larger public, which does not care for the histrionics of the art world."

Hans Haacke, Fall 1984

Opposite
Hans Haacke, *Broadness and Diversity of the Ludwig Brigade,* 1984, oil painting, photomural of billboard advertising Trumpf chocolate. Owned by the artist (Photos: Courtesy of the artist).
Executed for the one-artist exhibit "Hans Haacke: According to/After the Rules of the Game/Art," Künstlerhaus Bethanien, West Berlin, September–October, 1984.
In the background of the painting is the Trumpf ("trump") chocolate logo, one of seven brands produced by the Monheim group, headed by art collector and patron Dr. Peter Ludwig, who stands in front stirring a bowl of chocolate. The placard to the left reads "Solidarity with our fellow workers in the capitalist part of Berlin"; the one on the right says "9 DM/hour is not enough. Stop the job cuts at Trumpf."
For information on the background of the work, *see* Hans Haacke, "Broadness and Diversity of the Ludwig Brigade," *October* 30 (Fall 1984), pp. 9-16.

Above
Hans Haacke, *Oil Painting, Homage to Marcel Broodthaers,* 1982/83/84, oil painting in gold-leafed frame (35 1/2 x 29 in (90 x 73.5 cm) overall), brass plaque, picture lamp, brass stanchions and red velvet rope; red carpet; photomural (dimensions variable). Owned by the artist.
Installation photographs of its first exhibition, at Documenta 7, Kassel, West Germany, 1982 (Photos: Udo Reuschling).
The photomural differs depending on the place of exhibition; it always shows a peace demonstration in that country. The one exhibited at Documenta shows the largest demonstration held in Germany since World War II. An anti-nuclear protest, it occurred in Bonn— one week before Documenta opened—when President Regean arrived there to speak at the Bundestag (Parliament) in favor of basing NATO Pershing 2 and cruise missiles on German soil. The banner in the background reads "Reagan get lost—Neither NATO nor Warsaw."

"If the dissenting voices can become the mainstream chorus, as it happened, for example, toward the end of the Vietnam War, what more can we hope for?"

Hans Haacke, Fall 1984

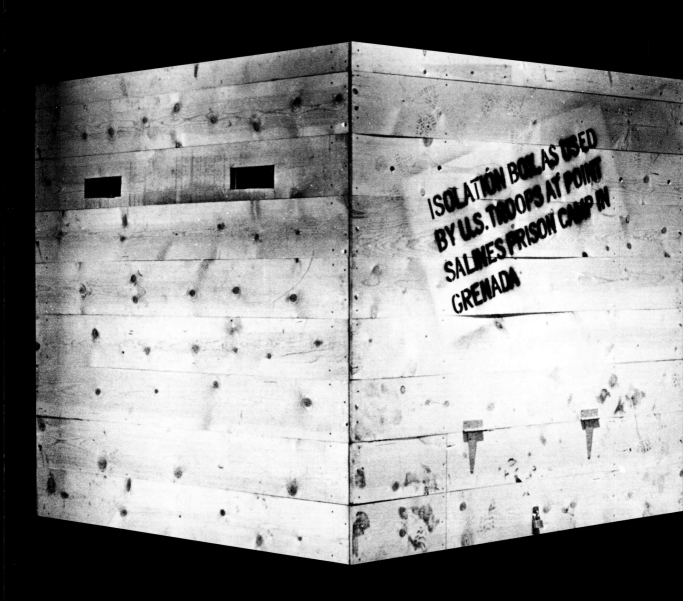

"The art world isn't *that* important."

Hans Haacke, Fall 1984

Hans Haacke, *U.S. Isolation Box, Grenada, 1983*, 1984, wood and metal, 8 x 8 x 8 ft (2.4 x 2.4 x 2.4 m). Owned by the artist (Photo: Courtesy of the artist).

This replica was based on a story by reporter David Shribman in *The New York Times*, 17 November 1983, and further information he gave the artist. Ten such boxes were found in the Point Saline's prison camp.

At one point during its first exhibition on a public mall at the City University of New York—in the Artists' Call Against U.S. Intervention in Central America exhibit, January 1984—the *Box* was shunted into a dark corner and turned so the text could not be read. Only after vigorous protests by the artist was the work returned to its original position.

"Let's not forget that we are not living in an ideal society. One has to make adjustments to the world as it is. In order to reach a public, in order to insert one's ideas into the public discourse, one has to enter the institutions where this discourse takes place."

Hans Haacke, Fall 1984

Hans Haacke, *The Goodwill Umbrella (detail),* 1976, four-color screenprint on acrylic, six panels, each, 48 x 36 in (121.9 x 91.4 cm), edition of three. Courtesy of the artist.

Hans Haacke, Robert Kingsley plaque from *On Social Grease,* 1975, one of six photogengraved magnesium plates mounted on aluminum, 30 x 30 in (76.2 x 76.2 cm) each. Collection of Gilman Paper Company, New York (Photo: Walter Russell, Courtesy of John Weber Gallery).

At an exhibition in May 1975, Robert Kingsley posed next to the plaque from Haacke's *On Social Grease* on which a quote from him (reproduced above) was printed. At that time Robert Kingsley was the manager of Urban Affairs, Department of Public Affairs, EXXON Corp., New York, and President, Arts and Business Council, New York. The quote was taken from a *New York Times* article titled "Business Aids the Arts . . . And Itself," by Marilyn Bender, 20 October 1974, Section 3, p. 1. (Photo: Impact Photo, Inc., New York; copied from *Hans Haacke, Framed and Being Framed.*)

1927
Edward Kienholz born in Fairfield, Washington, to Lawrence and Ella Eaton Kienholz. Grows up on family farm, learning various mechanical skills later important in his artmaking. Begins painting in oil and watercolor while in high school, but never attends art school. In the late 1940s, briefly attends two small colleges in eastern Washington. Works various jobs in the Northwest and West, including one in state-run hospital, managing a dance band, buying and selling used cars, owning a bootleg club, doing window display, selling vacuum cleaners, being an attendant in a mental institution, etc.

1943
Nancy Reddin born on December 9 in Los Angeles, California, to Thomas and Betty Parsons Reddin. Grows up in Los Angeles; attends University of Southern California for a short time. Works various jobs such as sales clerk, medical assistant, emergency hospital attendant, court reporter, etc.

1953
Kienholz moves to Los Angeles, California.

1954
Begins making low reliefs of scrap wood and painting them with house or auto paint using a broom; they are given "mostly satirical and social" titles, e.g., *They Tarred and Feathered the Angel of Peace.*

1955
Becomes involved in creating forums and alternative spaces for artists.

1956
In exchange for a year's rent, Kienholz remodels a theatre and opens the Now Gallery, run with open door exhibition policy. Organizes, with Walter Hopps, All City Outdoor Art Festival, including booths from established and alternative galleries.

1957
Hopps and Kienholz agree to open a gallery and start the Ferus Gallery. Kienholz maintains studio at back of gallery, showing little and mostly trading with other artists. His own art works become more specific and often figurative, increasingly incorporating found objects: "all the little tragedies are evident in junk."

1958
The Little Eagle Rock Incident, first work with a title related to a current event.

1959
First truly topical work, *God-Tracking Station*—"in case it sees Him, it takes his picture"—made in response to launching of Sputnik.
Begins making fully 3-dimensional constructions, e.g., *John Doe* and *Jane Doe.*

1961
Completes *ROXYS,* first full-scale environmental tableau, evoking a Las Vegas whorehouse in 1943. Exploitation and violation of women to become a recurring theme.

1963
Begins making "Concept Tableaux," works to be realized upon purchase rather than speculation.

1967
Completes first concept tableau, *The State Hospital* (concept 1964), expressing outrage at abuses witnessed while working in a mental hospital in 1948.
Because of its sexual subject matter, inclusion of *Back Seat Dodge '38* in exhibition at municipal Los Angeles County Museum of Art causes scandal. Kienholz begins spending summers in Hope, Idaho, a small town near the Canadian border, and winters in Los Angeles.

1968
ROXYS shown at Documenta 4, Kassel, West Germany, bringing Kienholz's work to attention of European public.
Eleventh Hour Final, criticizing media's role in acceptance and then rejection of Vietnam war.

1970-71
"Kienholz: 11 Tableaux" exhibit circulated to six European museums.
1972
Five Car Stud, depicting castration of black man by whites, creates a stir at Documenta 5.
Edward Kienholz and Nancy Reddin meet in Los Angeles, and begin working together, are married.

1973
Kienholzes go to West Berlin on a DAAD grant, and stay for one year working on *The Art Show* tableau. They then begin to alternate between winters in Berlin and summers in Hope.
Still Live, a tableau with a loaded gun connected to a random firing mechanism and pointed at a chair is included in ADA exhibition in Berlin. A number of visitors sit in chair. Piece is confiscated by police after three days.

1975-77
Guggenheim Fellowship. Creation in Berlin of *Volksempfängers* series, commenting on the power of the media and the Nazi use of radio propaganda to control a whole people during World War II.

1977
Opening of Faith and Charity in Hope Gallery, "independently financed and free from commercial competition" "to bring the best art we can find" to this rural area.

1979-83
Creation in Hope of Spokane hotel pieces.

1981
Announcement that henceforth all works will be co-signed Edward Kienholz and Nancy Reddin Kienholz and that credit for works created jointly should be granted retroactively from 1972.

1985
Ed and Nancy Kienholz still split their time between Berlin and Hope, and Ed continues to buy and sell used cars.

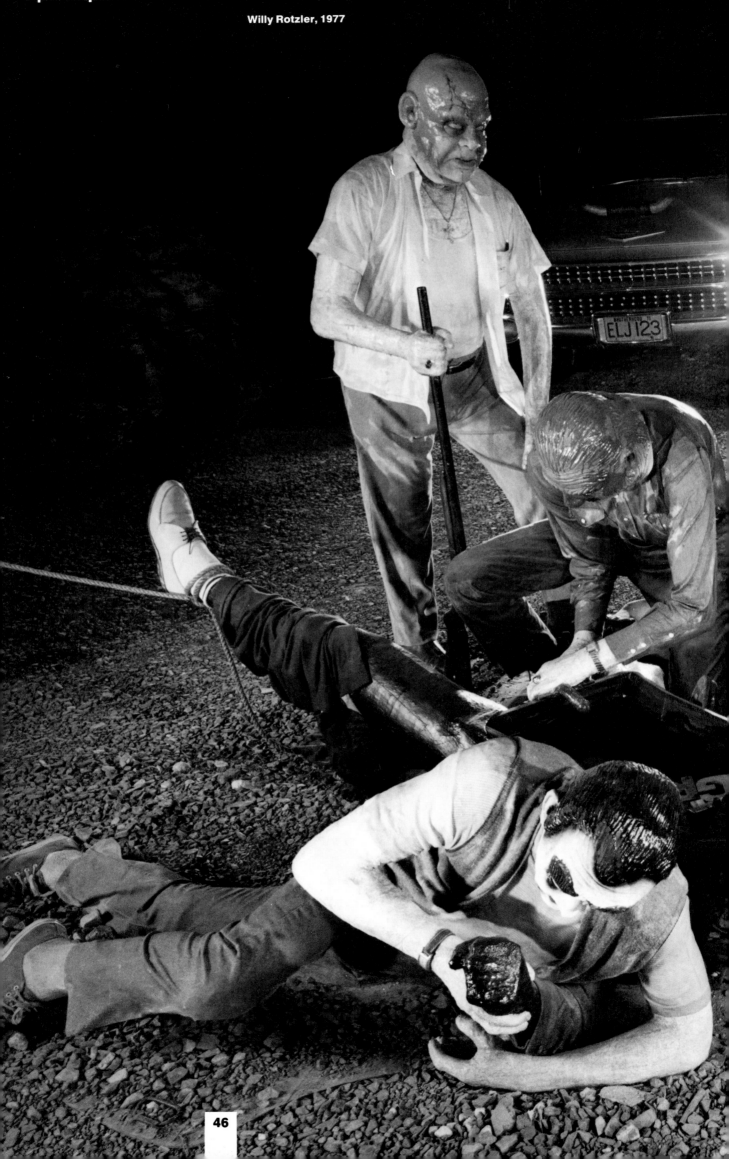

Kleinholz has repeatedly tried to break down the barrier between the work of art and the viewer, to force the observer out of the passive role of the curious or even prurient voyeur into the active one of a participant."

Willy Rotzler, 1977

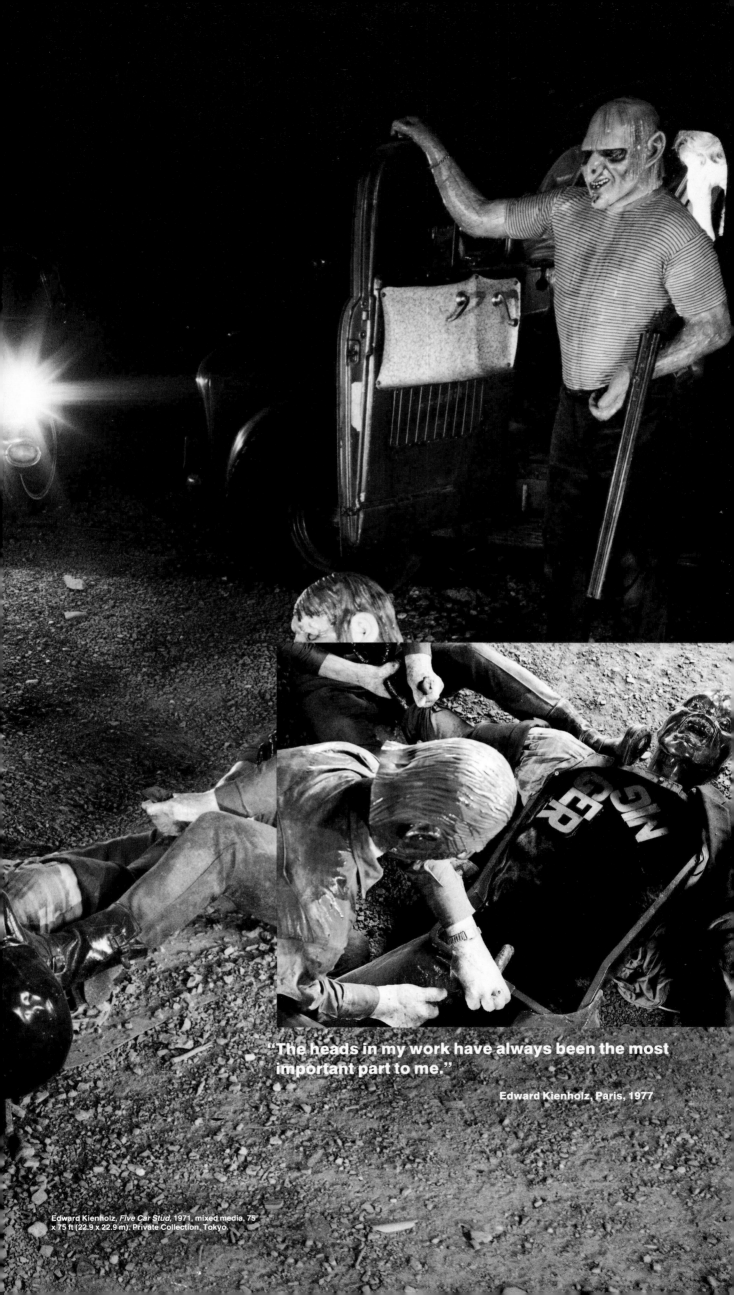

"The heads in my work have always been the most important part to me."

Edward Kienholz, Paris, 1977

Edward Kienholz, *Five Car Stud*, 1971, mixed media, 75 x 75 ft (22.9 x 22.9 m). Private Collection, Tokyo.

> **"Kienholz is at bottom a critic of society and of his times, and in the last analysis even a moralist."**
>
> **Willy Rotzler, 1977**

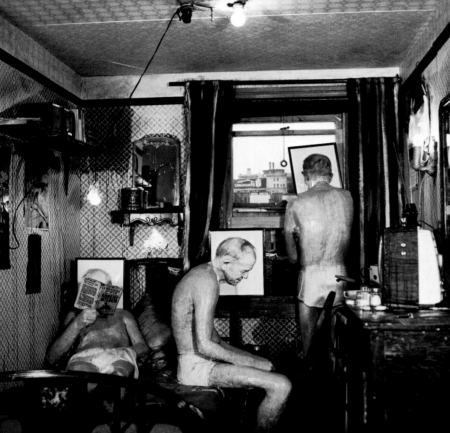

Edward Kienholz and Nancy Reddin Kienholz, *Sollie 17 (detail)*, 1979-80, mixed media, 10 x 28 x 14 ft (3 x 8.5 x 4.3 m). Private Collection, Los Angeles, Courtesy L.A. Louver Gallery, Venice, California (Photo: Nancy Reddin Kienholz).

> **"In all of Kienholz' art works . . . and in his approach to what it means to be an artist there seem to be two crucial objectives: power for an artist to re-define directly his place and role in society; an art that can become a real issue with a public concerned with more than social embellishment."**
>
> **Walter Hopps, 1967**

> **"Ed deplores the fact that women are sometimes today still used as 'dumping grounds' for man's physical and emotional advances."**
>
> **Nancy Reddin Kienholz, 1982**

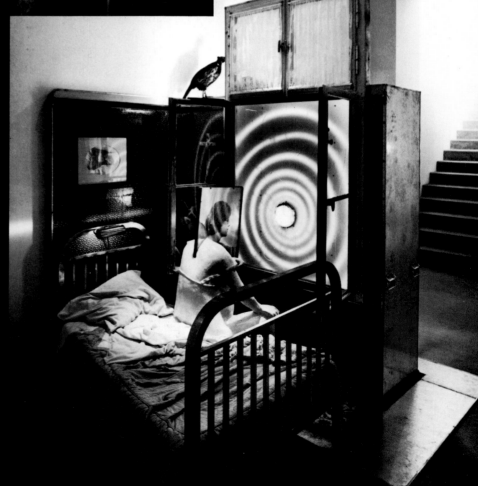

Edward Kienholz and Nancy Reddin Kienholz, *In the Infield was Patty Peccavi*, 1981, mixed media, 74 3/4 x 81 1/8 x 100 in (190 x 206 x 254 cm). Hirshhorn Museum and Sculpture Garden, Smithsonian Institution.

"Between Horror and Morality: The Work of Edward Kienholz"

Werner Spies, 1982

Edward Kienholz, *The Illegal Operation,* 1962, mixed media, 59 x 48 x 54 in (149.9 x 121.9 x 137.2 cm). Collection of Monte and Betty Factor, Los Angeles.

Edward Kienholz and Nancy Reddin Kienholz, *The Twilight Home,* 1983, mixed media, 85 x 23 x 52 in (215.9 x 58.4 x 132.1 cm). Collection Martin Margulies, Courtesy L.A. Louver Gallery, Venice, California.

Profile

Rock Video

Late 1940s
Appearance of the Panoram Soundie, a jukebox with film clip accompanying the song.

1948
Commercial television networks begin broadcasting in the U.S.

1955
Richard Brooks's film *Blackboard Jungle*, which is widely regarded as first rock and roll movie.

1957
Elvis Presley makes first appearance on *The Ed Sullivan Show*. Presley film *Jailhouse Rock* has stylized dance number which anticipates music video. *American Bandstand* with Dick Clark debuts on ABC.

1963
Underground filmmaker Kenneth Anger's *Scorpio Rising* relies heavily on rock and roll as narrative device.

1964
Richard Lester's Beatles movie *A Hard Day's Night* makes extensive use of quick cutting and cinema verité techniques. *Shindig*, a rock and roll variety show, airs during prime time on ABC (asst. director is David Mallet, who later produces many rock videos for the likes of David Bowie).

1965-66
Rock bands begin to make film clips for self promotion. Most are of performances, some have band lip-synching song in some other setting.

1966
The Monkees, a rock and roll sitcom, begins a two year run on NBC; style resembles Lester's *Hard Days Night*. Monkee Michael Nesmith later becomes a pioneer music video producer.
Precursor of later "concept" clips, the Kink's *Dead End Street*, with almost no lip-synching; The Who's *Happy Jack*, with no lip synch, follows next year.

1967
After they cease touring, the Beatles— with avant-garde filmmaker Peter Goldmann—produce and direct the surrealistic films "Strawberry Fields Forever" and "Penny Lane," and then send them to stations for airing; confused reactions garnered on *American Bandstand*.

1969
San Francisco's KQED airs video art series exploring relationship between music and visual imagery; includes Terry Riley's *Music with Balls* and Frank Zappa's *Burnt Weenie Sandwich*.

1970
Lick My Decals Off Baby, a 60-second TV commercial made by Captain Beefheart and his Magic Band for the album of the same name (is not aired).
Musical scenes from Nicolas Roeg's film *Performance*—starring Mick Jagger— almost indistinguishable from contemporary rock videos.

1971
Frank Zappa's *200 Motels*, first full-length feature shot on color video and using video effects (transferred to 35mm film for theatrical distribution).

1973
In Sydney, Russell Mulcahy and Graham Webb join forces to make promo films for Australian bands.

1974
In New York, Ed Steinberg begins taping punk acts (Patti Smith, Ramones) for local cable outlets.

1975
San Francisco performance artist Joe Rees begins documenting punk bands because of their "political and social commitment"; incorporates found news and newsreel footage; in 1977 forms Target Video.
Inspired by Zurich Dada, Sheffield, England, art students Steve Mallinder and Richard Kirk choose music and video as best means for voicing their ideas, form Cabaret Voltaire.
The Residents "Land of 1,000 Dances" makes references to Dada performances. *Nightclubbing*, featuring videotapes of punk band performances plays on Manhattan cable TV. Over next few years cable develops somewhat as an alternative music venue.
By this time, England's *Top of the Pops* and other European TV shows make extensive use of video clips, mostly performance; a few record companies become interested in their promotional value after Queen's "Bohemian Rhapsody" clip is largely responsible for making the song number 1.
Keefco Productions, producer of over 600 videos, formed in London by Keith McMillan and John Weaver.
Tommy, Ken Russell's extravagant rock opera film, prefigures music video aesthetics.
Sony introduces the Betamax, the beginning of the home video market.

1976
Devo, rock group from Akron, Ohio, makes films for songs "Jocko Homo" and "Secret Agent Man." Devo's Gerald Casale and filmmaker Chuck Statler go on to make many pioneering video clips—e.g., "It's a Beautiful Day" (1981)—promoting the band's message of the devolution of humanity.
In England, Russell Mulcahy meets John Roseman—whose production company has almost been a school of rock video— who pairs Mulcahy up with "conceptualist" Keith Williams. These two go on forge the premiere style of concept videos, often relying on elaborate staging (even on low-budgets).

1977
Warner Brothers Records founds Video Department, the first important recognition of the new form by a major American record company.
Founding in London of Rough Trade, a record shop, record label and leading distributor of independently produced hardcore, reggae and experimental records and videos.

1979
Mulcahy directs The Buggles's "Video Killed the Radio Star," including iconic image of a mountain of TV sets erupting through floor of a room of 1930s radios. Rough Trade (America) opens in San Francisco.

1980
Ed Steinberg forms RockAmerica to supply tapes to clubs that play new wave videos (number increases from 10 in 1980 to 400 by 1984).
Graeme Whifler, experimental filmmaker, directs The Residents's "One Minute Movies" and goes on to produce a number of other rock video classics.

1981
Michael Nesmith's Pacific Arts releases *Elephant Parts*, a full-length video album. In March, USA Cable Network premieres *Night Flight*, an amalgam of rock videos, rock films, video art, etc.
On August 1, MTV (MusicTeleVision)—a 24-hour, music video network showing promotional clips supplied by record companies—begins broadcasting; first video is The Buggles "Video Killed the Radio Star." Conceived for national market, begins with 4,000 subscribers.

1982
Museum of Modern Art, New York, begins collecting rock videos, including Captain Beefheart, Talking Heads, Laurie Anderson and Toni Basil.
On September 1, MTV enters New York and Los Angeles cable market, the turning point in rock video's success, popularity and sophistication (reaches 14 million households by this time).
Peter Gabriel's "Shock the Monkey" video's use of dwarfs and shamanistic symbols shocks mainstream music video community.

1983
Adriane Lynne's *Flashdance*, the first movie to rely heavily on music video aesthetics and techniques.
Michael Jackson's "Beat It" video directed by TV commercial director Bob Giraldi sets pattern for large budget extravaganzas.

1984
Zbigniew Rybzcynski directs Art of Noise's *Close to the Edit;* includes scene of young child (younger generation) destroying traditional musical instruments.

1985
Increasing number of protests about violence and sex in music videos, directed mainly at MTV as the major commercial outlet (20 million subscribers).
Telecast of "Live Aid" concerts in London and Philadelphia over MTV raises over 75 million dollars for famine relief in Africa. Rock given a valuable tool for political stance.

Compiled with the assistance of Alan Bloom and Robert Vianello.

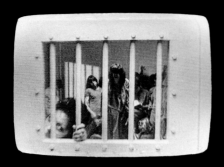

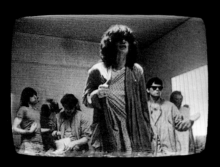

"According to the 1983 Neilsen Home Video Index, MTV's viewers are mostly in the 12-to-34-year-old age range, with a median age of 23. MTV now has a subscription base in excess of 20 million viewers."

Video Consumer Profile, July 1985

"'Institutionalized,' by the L.A.-based punk band Suicidal Tendencies, was voted one of 1984's 10 best videos by the *Los Angeles Times'* music/video critics and given somewhat dubious honors by *Hustler* magazine as the year's best hard-core video. It was also among the year's 20 best on ABC's 'Goodnight L.A.'"

Michael Kelem, 1985

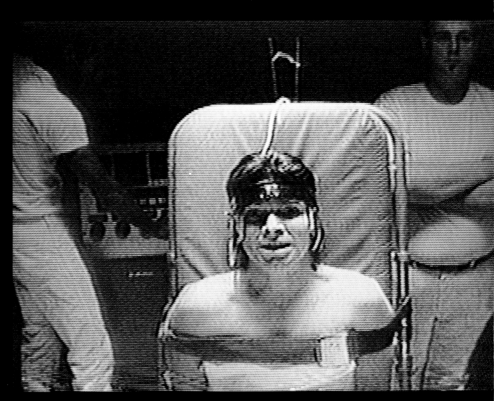

The Ramones, "Psycho Therapy," 1983 (from the Sire Records album *Subterranean Jungle*), produced and directed by Francis Delia for Wolf Co.

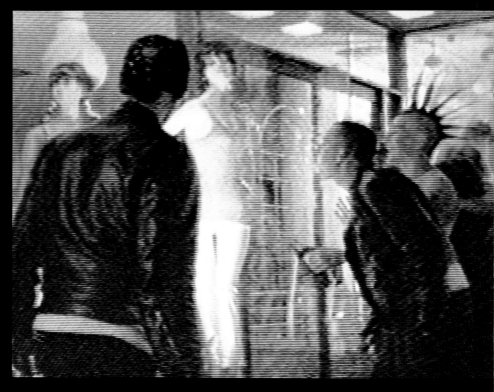

Ian Messenger, "Livin' in the Night," 1985 (from the Quest Records album *Livin' in the Night*), directed by Douglas Gayeton and produced by Bill Longenheim for Brass Ball.

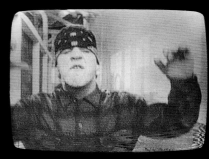

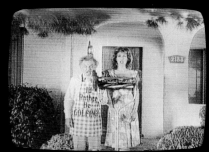

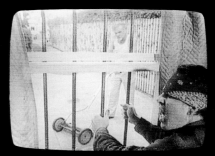

Suicidal Tendencies, "Institutionalized," 1984 (from the Frontier Records album *Suicidal Tendencies)*, produced and directed by William Fishman for Fallout Films.

Wait! Whattaya talking about, "we" decided? "My best interest," how do *you* know what *my* best interest is? How can you say what *my* best interest is? Whattaya trying to say, *I'm* crazy??
I went to *your* schools. I went to *your* churches. I went to *your* institutional learning facilities! So how can you say *I'm* crazy?!?

"Institutionalized," Suicidal Tendencies, 1984

The Residents, "Hello Skinny," 1980 (from the Ralph Records cassette *Ralph Video Volume 1)*, directed by Graeme Whifler and produced by Graham Whifler and The Residents for Cryptic Corporation.

"I think of this stuff as nightmares of the baby boom generation."

Graeme Whifler, 1985

Stills from 1985 documentary on Cabaret Voltaire (Richard Kirk and Steve Mallinder) that was aired on USA Cable Network's &Night Flight. This footage preceded Cabaret Voltaire's clip "Crack Down," (produced and directed by Richard Kirk and Steve Mallinder for Cabaret Voltaire), which uses similar found footage.

Top three images, The Residents, "Land of 1,000 Dances," 1975 (from the Ralph Records album *Third Reich and Roll*), produced and directed by The Residents for Cryptic Corporation.

Fourth image, The Residents, "Act of Being Polite," from *One Minute Movies*, 1980, directed by Graeme Whifler and produced by The Residents for Cryptic Corporation.

"We thrive on contradictions, we thrive on paradoxes, we thrive on ambiguities, that's the thing we're based on. . . . We work on the ambiguities that everybody lives with, every day of their life—when they eat, sleep, dream, when they talk, when they work. They're full of contradictions and we thrive on them. We love to work on them, and push them back at people so that they can actually confront themselves in a different way."

Steve Mallinder of Cabaret Voltaire, 1985

It's a beautiful world we live in
A sweet romantic place
Beautiful people everywhere
The way they show they care
Makes me want to say
It's a beautiful world
It's a beautiful world
It's a beautiful world
For you, for you, for you
It's a wonderful time to be here
It's nice to be alive
Wonderful people everywhere
The way they comb their hair
It's a wonderful place
It's a wonderful place
It's a wonderful place
For you, for you, for you
Hey tell me what I say
Boy and girl with the new clothes
 on
You can shake it to me all night
 long
Hey, Hey
It's a beautiful world we live in
A sweet romantic place
Beautiful people everywhere
The way they show they care
Makes me want to say
It's a beautiful world
It's a beautiful world
It's a beautiful world
For you, for you, for you
It's not for me

It's a beautiful world
It's a beautiful world
It's a beautiful world
For you, for you, for you
Not me

"Beautiful World," Devo, 1981

"We *never* approached video as a promotional afterthought. It was *always* an integral part of our artistic whole. We had messages and information to communicate, imagery to show people, and we documented it and showed it to people. But strong imagery like that, and messages that run any deeper than 'I'm pretty—buy me' scare the power brokers of the entertainment industry, so it's a no-no. Devo is a bunch of bad boys in their eyes."

Gerald Casale of Devo, 1984

"Devo was actually a futuristic protest band, whose target was nothing less than humanity itself."

Michael Shore, 1984

Devo, "Beautiful World," 1981 (from the Warner Brothers album *New Traditionalists),* directed by Gerald Casale and produced by Chuck Statler for DevoVision.

Bibliography

Included in the following bibliographic selections are the sources of the quotes found in the artists' profiles.

Chris Burden

Chris Burden 71-73. Privately published by the artist, Los Angeles, 1974.

Robert Horvitz, "Chris Burden," *Artforum* 14, no. 9 (May 1976), pp. 24-31.

Chris Burden 74-77. Privately published by the artist, Los Angeles, 1978.

Fred Hoffman, "Chris Burden's Humanism," *Artweek,* 27 October 1979, pp. 1, 16.

Chris Burden and Jan Butterfield, "Through the Night Softly," in *The Art of Performance: A Critical Anthology* ed. Gregory Battcock and Robert Nickas (New York: E.P. Dutton, 1984), pp. 222-39.

Christopher Knight, "Artist Chris Burden rediscovers tradition," *Los Angeles Herald Examiner,* 22 January 1984.

Donald Kuspit, "Chris Burden, Dennis Oppenheim, Artpark," *Artforum* 23, no. 4 (December 1984), p. 88.

"Chris Burden, July 1985," conversation with Chris Bruce, Henry Art Gallery, July 1985.

Hans Haacke

Jeanne Siegel, "An Interview with Hans Haacke," *Arts Magazine* 45, no. 7 (May 1971), pp. 107-13.

Framed and Being Framed, texts by Jack Burnham and Howard S. Becker and John Walton (Halifax: The Press of the Nova Scotia College of Art and Design, 1975).

Hans Haacke, Volume 1, exh. cat., texts by Hans Haacke and Margaret Sheffield (Oxford and Eindhoven: Museum of Modern Art, Oxford, and Stedelijk van Abbemuseum, 1978).

Hans Haacke: Recent Work, exh. cat., text by Jack Burnham (Chicago: The Renaissance Society of the University of Chicago, 1979).

Hans Haacke, Volume 2, exh. cat., texts by Hans Haacke and Tony Brown (Oxford and Eindhoven: Museum of Modern Art, Oxford, and Stedelijk van Abbemuseum, 1983).

Jeanne Siegel, "Leon Golub/Hans Haacke: What Makes Art Political," *Arts Magazine* 58, no. 8 (April 1984), pp. 107-13.

Yves-Alain Bois, Douglas Crimp and Rosalind Krauss, "A Conversation with Hans Haacke," *October* 30 (Fall 1984), pp. 23-48.

Hans Haacke, 4 Works: 1983-1985, exh. cat., text by Hans Haacke, (New York: John Weber Gallery, 1985).

Rock Video

To date, very little has been published on the subject. The first two sources listed are essential.

Michael Shore, *The Rolling Stone Book of Rock Video* (New York: Rolling Stone Press, A Quill Book, 1984).

Optic Music Magazine, a trade journal published in Los Angeles, which is two years old.

"Beautiful World," by Mark Mothersbaugh and Gerald Casale, from the Devo album *New Traditionalists* (Warner Brothers). Copyright © 1981 Devo Music/Nymph Music, Inc.

"Institutionalized," by Mike Muir and Louiche Mayorga, from the Suicidal Tendencies album *Suicidal Tendencies* (Frontier Records). Copyright © 1984 American Lesion Music/You'll Be Sorry/Adm. by Bug.

Michael Kelem, "Notes from the Underground: Fallout Films," *Optic Music* 2, no. 4 (July 1985), pp. 20-22.

Myles E. Mangram, "Video Consumer Profile," *Optic Music* 2, no. 4 (July 1985), p. 6.

Linda Regensberger, "Music Video Goes to College," *Optic Music* 2, no. 4 (July 1985), pp. 24-25.

"Graeme Whifler, 1985," Conversation with Chris Bruce and Douglas Wadden, Los Angeles, August 1985.

Llyn Foulkes

Llyn Foulkes: Fifty paintings, collages and prints from Southern California Collections, a survey exhibition—the years 1959-1974, exh. cat., text by Sandy Ballatore and Llyn Foulkes (Newport Beach: Newport Harbor Art Museum, 1974).

H.J.S. [Henry J. Seldis], "Art Walk: La Cienega," *Los Angeles Times,* 19 April 1974, p. IV:10.

William Wilson, "Foulkes: Haunting, Intuitive," *Los Angeles Times,* 16 October 1974, p. IV:4.

Llyn Foulkes: New Works, 1976-1977, exh. cat., text by Stephen Bann (New York: Gruenebaum Gallery, 1977).

Alan G. Artner, "Canvas and cowbells add to the enigma of Foulkes," *Chicago Tribune,* 21 May 1978 ("Llyn Foulkes, 1978").

"Llyn Foulkes, 1984," inscription on his painting *Rabyn's Rock.*

Edward Kienholz and Nancy Reddin Kienholz

Edward Kienholz, exh. cat., text by Maurice Tuchman (Los Angeles: Los Angeles County Museum of Art, 1966).

Works from the 1960's by Edward Kienholz, exh. cat., texts by Walter Hopps and Marcus G. Raskin, (Washington, D.C.: Washington Gallery of Modern Art, 1967).

Edward Kienholz: 11 Tableaux, exh. cat., text by Pontus Hulten (London: Institute of Contemporary Arts, Nash House, 1971).

The Art Show, 1963-1977, exh. cat., text by Edward Kienholz (Paris: Centre National d'Art et de Culture Georges Pompidou, 1977).

Edward Kienholz: Volksempfängers, exh. cat., texts by Willy Rotzler, et. al. (Zürich: Galerie Maeght, 1977) ("Edward Kienholz, Berlin, 1977").

Edward Kienholz: Still Live, Projekt für Aktionen der Avantgarde (ADA) 2, exh. cat., texts by Thomas Deecke, Edward Kienholz and Roland H. Wiegenstein (Berlin: Neuer Berliner Kunstverein e.V., 1975).

The Last Time I Saw Ferus, 1957-1966, exh. cat., text by Betty Turnbull (Newport Beach: Newport Harbor Art Museum, 1976).

Edward Kienholz: ROXYS and Other Works aus der Sammlung Reinhard Onnasch, exh. cat., text by Nancy Reddin Kienholz, et. al. (Bremen: GAK—Gesellschaft für Aktuelle Kunst e.V., 1982).

Edward Kienholz, Nancy Reddin Kienholz: The Berlin Women, exh. cat., texts by Edward Kienholz, Nancy Reddin Kienholz and Heinz Ohff (Berlin: Dibbert Galerie, 1982).

Werner Spies, "Between Horror and Morality: The Work of Edward Kienholz," in *Focus on Art,* (New York: Rizzoli, 1982), pp. 185-90.

Edward and Nancy Reddin Kienholz: Human Scale, exh. cat., texts by Edward Kienholz, Lawrence Weschler and Ron Glowen, (San Francisco: San Francisco Museum of Modern Art, 1984).